DISASTER
ON THE
POTOMAC
THE LAST RUN OF THE STEAMBOAT WAWASET

ALVIN F. OICKLE

Charleston London

THE
History
PRESS

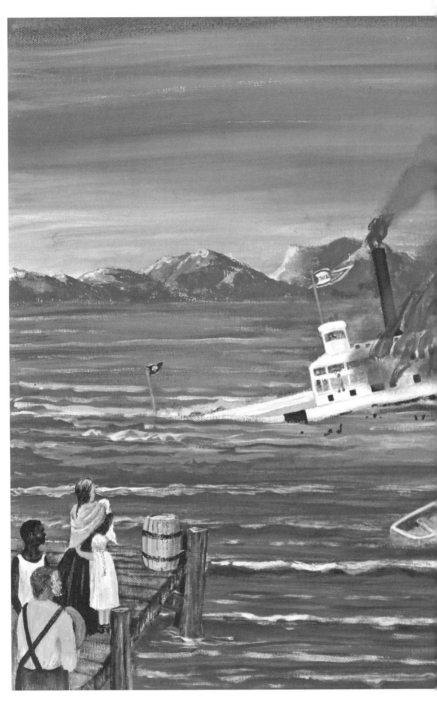

This illustration, from a painting by Anne R. Dolan, shows the sinking *Wawaset* in flames. The painting, rendered in acrylics, reflects a naïve style common to the nineteenth century. *Painting © 2009 Anne R. Dolan. All rights reserved.*

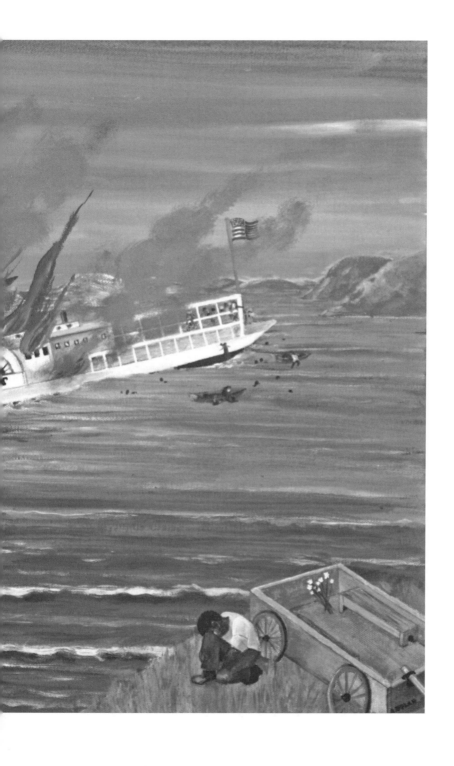

Published by The History Press
Charleston, SC 29403
www.historypress.net

First published 2009

Manufactured in the United States

ISBN 978.1.59629.813.2

Library of Congress Cataloging-in-Publication Data

Oickle, Alvin F.
Disaster on the Potomac : the last run of the steamboat *Wawaset* / Alvin F. Oickle.
p. cm.
Includes bibliographical references.
ISBN 978-1-59629-813-2
1. Wawaset (Steamboat) 2. Fires--Potomac River--History--19th century. 3. Disasters-
-Potomac River--History--19th century. 4. Ships--Fires and fire prevention--Potomac
River--History--19th century. 5. Steamboats--Potomac River--History--19th century. 6.
Potomac River--History--19th century. 7. Washington Region--History--19th century.
I. Title.
F187.P8O385 2009
975.5'29--dc22
2009043988

Contents

Acknowledgements

More than any other book-writing project in which I have been involved, *Disaster on the Potomac* brought together exceptional voluntary assistance from a large number of dedicated professionals. The first help came from Sandra Schmidt, historian at the Historic Congressional Cemetery in Washington. She provided information on that famous old burying ground and then went far beyond in offering help with nineteenth-century Washington newspapers and other sources. She was fast and efficient in responding to all my queries and in developing leads to new and significant information.

Quick, helpful responses also came for every request I sent to Elizabeth Lee, curator at the King George County Historical Society Museum in Virginia. She often had an answer in memory but, true historian that she is, checked it and provided an authoritative source. Much of the vital information about King George County residents came from Elizabeth. She and her assistant, Jean Moore Graham, were also ready with their cameras when I needed help.

Images make up a major part of this project, and here, too, I had exceptional support. John C. Villforth, who lives in Maryland, was with his daughter's family in Virginia the day I arrived to study the area where the main action in this story takes place. John volunteered first to make photographs and then to prepare all images for publication. He brought more than a camera to the effort, and I am pleased to have had him with me in the project.

These three—Sandra, Elizabeth and John—greatly assisted in making easier my task of researching text and finding appropriate photos, drawings and other images. They have earned both gratitude and admiration.

Two paintings are reproduced in this book. The older one, by Carrol Morgan of King George, hangs in the county courthouse, a gift at America's bicentennial in 1976. The newer painting is shown inside. This work was created for this book by Anne R. Dolan of Maine, who partnered with me on a Cape Cod book nearly a decade ago. She explained her style:

> *The style of painting that I have chosen to portray the burning and sinking of the* Wawaset *reflects my feeling about the simplicity of the people waiting for the steamboat, an attention to detail that the event demanded and a certain reflection of the naïve illustration mode of that era. It is therefore an unsophisticated depiction of the horror and attendant emotions painted with as much historical accuracy as possible.*

Part of Anne Dolan's challenge came in painting the wreck of a steamboat for which we could not find a picture. What did the *Wawaset* look like? The Mariners Museum staff in Newport News, Virginia—reputed to have the nation's largest collection of images related to vessels—could not find a photo or drawing of the *Wawaset*. Jessica M. Palen, coordinator of photographic services, Bill Barker and Claudia Jew spent hours on the search. We finally settled for a look-alike image of the *Governor Safford*.

I have tried to help readers follow the story on a personal level by writing about two women who died in the disaster. They are Alethea ("Lethy") Garnett Gray and Sarah ("Sallie") Walker Reed. Some of Mrs. Gray's story comes from a personal note and a genealogical website created by one of Lethy's descendants, Arica Coleman.[1] An assistant professor of Black American Studies at the University of Delaware, Dr. Coleman also has my thanks for the encouragement she gave me to write about the racial politics that invaded life at all levels in the years after the Civil War. How the people treated one another is, and should be, a part of this story. Special thanks go to Sandra Schmidt for help with the Reed family background and to Elizabeth Lee for information about the Gray family.

I had special assistance in understanding the Potomac from Francesca Henle Taylor, information technology manager for Westmoreland County, Virginia, whose e-mail address tells where she stands. It includes the words "history buff" and "research." I was given an on-the-spot tour by a father/son team who own and operate Seament Shoreline Systems, Inc. Dr. S.E.

Veazey is a retired navy captain and U.S. Naval Academy graduate; his son, Warren T. Veazey, is a U.S. Merchant Marine Academy graduate and retired maritime officer. The Veazeys have intimate knowledge of the river, which they love. Their homes are on the Potomac's banks near Chatterton's Landing, which I think of as Ground X in this story, and they work there designing and installing protective shoreline structures.

Help also was given by Terri Thaxton, executive director of the Steamboat Era Museum in Irvington, Virginia. The museum is filled with exhibits of boats and river travel and also emphasizes the "era" in its title through displays and records of nineteenth-century life.

The "Great Eastern Bend" of the Potomac River is home to others whose interest in the *Wawaset* and regional history benefited me. They included Dr. Susan Langley, Maryland state underwater archaeologist; Carol Arnott and Marie Bailey, circulation aides at the L.E. Smoot Memorial Library in King George; Odile Pryor of the Reference Department, Central Rappahannock Regional Library in Fredericksburg, Virginia; Sandra W. Freeman, information technology manager, King George County; James F. Mullen, former president, King George County Historical Society; William B. Bynum, Archives Research Services, and Catherine Bond, Library of Virginia in Richmond; Kathe Gunther, volunteer researcher in the Virginia Room, City of Fairfax Regional Library; and Robert Hodge and Gary Stanton of Fredericksburg, who compiled an index and prepared a website with valuable *Fredericksburg Ledger* clippings. Research in Richmond was carried out by Alice Cox Phillips.

In Wilmington, Delaware, help came from Jon M. Williams, the Andrew W. Mellon curator of prints and photographs, and Marjorie McNinch, reference archivist, Manuscripts and Archives Department, Hagley Museum and Library; Renee O'Donnell, reference librarian, Wilmington Public Library; and Ed Richi, librarian, Research and Reference Services, Delaware Historical Society.

Also offering help were Diane P. Rofini, librarian, Chester County Historical Society, West Chester, Pennsylvania, and Janet Swanbeck, reference librarian, University of Florida in Tallahassee.

The Library of Congress and the National Archives and Records Administration (NARA) in Washington are two of the best resources any history writer could have. The professionals there often function without revealing their identities in performing clear, and sometimes intensely deep, investigation on behalf of the researcher. I am grateful to all who helped and can identify a few among them. Amber Paranick, reference specialist in

the Serial and Government Publications Division, Newspaper and Current Periodical Room, at the Library of Congress, was quick to find works I sought. At NARA, Mark C. Mollan of the Old Navy-Maritime Reference Archives I-Textual Reference Services Division, and Matthew Jordan of Textual Archives/Old Military and Civil Records were especially helpful. Beth Bensman, archives specialist at NARA's Mid-Atlantic Region, helped direct my search.

Finally, and most important on a personal level, I extend my gratitude to my companion, Herta Rasch. Her patience in enduring my ridiculous work schedule and her comforting assistance at home made huge contributions to my ability to accomplish this project.

INTRODUCTION

A steamboat called the *Wawaset* had completed about half her routine run from Washington down the Potomac River on an August day in 1873 when she unexpectedly became history. Her story is among many that begin with the joy of adventure and end in tragedy; in the case of the *Wawaset*, the tragedy cost the lives of seventy or more children, women and men. But there is more to this story. The paddle-wheel vessel's sinking offers a glimpse of American life and culture unfamiliar in the twenty-first century.

A dependence on riverboats for routine chores was already waning in the 1870s. However, the *Wawaset* was a necessary link between small communities in Virginia and Maryland and the relative giant that was Washington City. On one level of morality, this is the story of maritime officers who hedged legal requirements, ignored rudimentary safety training and even carried on a moonlighting business in trade while being paid to run a ferry and excursions. Some of these officers were put on trial twice—at a local inquest and before a far more serious federal board. The end of slavery in the mid-1860s brought to the nation unfamiliar challenges that would be most difficult to overcome. Historian Paul Johnson put it this way: "The end of the Civil War solved the problem of slavery and started the problem of the blacks, which is with America still."[2] Brought into the harsh light of modern examination, life in and around the nation's capital city might seem to us now equally as disgusting for its lack of courtesy and respect. And nothing can be more upsetting than the loss of life—six in the

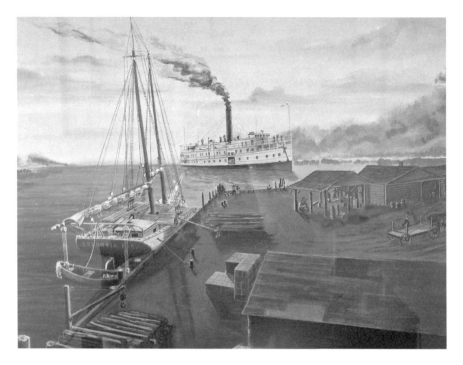

"Steamboat's a-coming!" was a welcome cry at many small landings along the Potomac River. This mural is at the Steamboat Era Museum in Irvington, Virginia. *Photo by Jean Graham.*

Joseph Reed family, four each in the Grant-Lynch and Griffin families and two in several others.

Seen tethered to a wharf in Washington, who would have thought that the *Wawaset* was about to become a symbol? She might be remembered by some for her reputation as a fancy excursion boat. A full reading of the record, however, may leave more of us sensitive to other memories. There was the unforgivable failure of the boat's captain to have his crew prepared for disaster. There were the despicable practices of greed by several of the *Wawaset*'s officers and the company that owned the vessel. Continued discrimination against African Americans was also carried out aboard this boat on her last trip. Regional attempts to integrate public transportation were seldom successful this soon after slavery's end.[3]

When quoting from printed material, I have copied the varied spellings used; for example, "negro" and "Negro." I have also repeated in context other terms designating race. This was America in the 1870s. The *Ledger* newspaper in Fredericksburg, the largest Virginia city near King George County, followed the practice of other newspapers in the South in identifying

people, often telling what the writer did not know, as well as what he did. The following are three examples from the *Ledger*:

> *The store of Charles Grayson, colored, on Commerce Street, was entered last Thursday by some thief.*

> *It is reported that the fireman on an engine was accidentally killed at Quantico on last Monday...We never heard whether he was white or colored.*

> *Mr. Simon Elgin, a deaf and dumb man from Prince William County, died...on the 17th instant. His age was unknown.*

The focus of this story will be on people like Charles, Simon and the fireman, people who led ordinary lives and who happened to board the *Wawaset* the day of the steamer's last run on the Potomac River. Special attention will be paid to two young women whose lives were centered on family. Alethea Garnett Gray, called "Lethy," was black and had four children with her husband, Cornelius Gray. Sarah Walker Reed, known as "Sallie," was white, had three stepchildren from her new husband, Joseph Reed, and, according to some sources, was pregnant. Both women grew up near the landing where much of the story's action is centered. There is no evidence that they knew each other or, for that matter, even knew each other existed.

Lethy and Sallie began the trip like all of the *Wawaset*'s passengers—male and female, white and black, single and married, homebound and vacationing—all of them alive. The two women were among the many who would not survive.

Chapter 1

Boarding for an Excursion

The quiet and damp of early morning were cloaking the Seventh Street Wharf in Washington, D.C., that Friday morning when Lorenzo Brown and John Foreman reported for duty aboard the *Wawaset*. They were able to see "the full moon in the west grow pale and disappear in the morning light," as Walt Whitman was to recall of his time living in Washington. The poet described the Washington summer as "hot and dull."[4] What better way to escape the heat than to ride a boat on the Potomac?

Brown and Foremen were firemen. Their early duties were to clean the firebox, load it with coal and start a fire under the boiler. Steam from the heated water was used to drive the engine's pistons to turn a driveshaft that, in turn, rotated the paddle wheels on the boat's sides. The crew had developed sea legs long ago. As they shoveled coal into the firebox, the firemen's bodies rocked with the slight sway caused by the river's lapping at the docked steamboat.

The word "firefighter" had not yet been invented, but as events turned out that Friday, August 8, 1873, it might have been better if they had been firefighters and not firemen.

The *Wawaset* was considered one of the region's best-appointed river steamboats. For that reason alone, it is understandable that she would be overloaded with passengers and cargo on a hot summer day. As it happened, on August 8, a trade journal was to report, "the steamer had a large cargo of freight for river landings."[5]

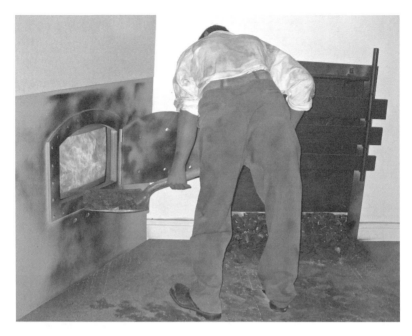

Steam for riverboats came from burning coal beneath boilers. This fireman's model is at the Steamboat Era Museum in Irvington, Virginia. *Photo by Elizabeth Lee.*

The *Wawaset* had been a wooden workhorse from her construction by the reputable Pusey & Jones in Wilmington, Delaware, in 1863. A Philadelphia firm had ordered the steamer built, intending that she should run fruit from Duck Creek and Smyrna to the Pennsylvania city, but she was soon after taken over by the Union army for use as a troop transport vessel. The *Wawaset* served as a hospital transport during the last year of what southerners call the War Between the States. That service was on the Potomac River, in and out of land projections that were sometimes without wharf or landing.[6] Belle Plain, Virginia, was an example of a port created by a naval task force—simply by its offshore presence during one of General U.S. Grant's final campaigns in Virginia.

Dr. Henry T. Child wrote to his wife from "on board the *Wawaset*, Aquia Creek, at Belle Plain, May 12, 1864." Union soldiers, he said, were

placing the wounded men on the boat. More than 3,000 were sent to Washington this afternoon. This morning, Surgeon Cuyter detailed me to go in the boat...with 527 wounded men...I only stay a little while in Washington while we unload the men & take in the coal.[7]

The Last Run of the Steamboat *Wawaset*

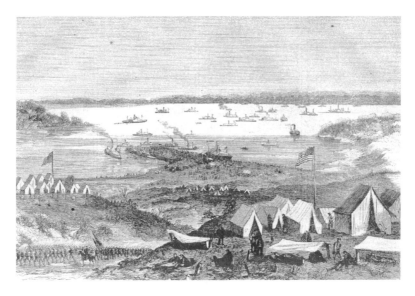

The *Wawaset* may have been among the many Union steamboats anchored off a newly constructed Potomac Creek landing called Belle Plain, Virginia. Fredericksburg is nine miles distant. This area, a New York newspaper told its readers on June 11, 1864, "was constantly crowded with transports and naval vessels, receiving and unloading stores and troops; and the scene from the heights on a clear day was almost as full of life and animation as New York Harbor." *From a sketch by A.R. Waud,* Harper's Weekly.

After the war, the *Wawaset* joined the fleet owned by the Washington Ferry Company.[8] She was a ferry when passengers and freight needed rides up and down the nearly one hundred miles between Washington City, as it was known, and the many small wharves and landings along the way to Chesapeake Bay.[9] And when a church or other celebrating group wished to rent the boat for a daylong excursion, the *Wawaset* was available. Such was the case for the *Express*, as well, which was scheduled to return that Friday to Washington from Point Lookout with a boatload of partying Painters' Union members and guests. For this round trip of nearly two hundred miles, the *Express* would have provided overnight facilities for the passengers. At 172 feet, this vessel was a third longer than the *Wawaset* (129 feet). Just the month before, the *Washington Morning Chronicle* had sponsored a free excursion to Glymont, Maryland, for city children.[10]

Smaller than many of the vessels docked at the Seventh Street Wharf, the *Wawaset* listed her tonnage at 258,[11] much lighter than the *Vanderbilt* (3,360 tons) and even the *Express* (275 tons).[12] The *Wawaset* was only twenty-six feet at her widest, with a hold measured at nine feet[13] and

two decks above. This smallish vessel sometimes carried as many as five hundred passengers.

The *Wawaset*'s builders never intended for her to compete with the *Express* and others of the "more prestigious, even glamorous, steamboats…leaving Baltimore on widely advertised schedules for Washington and the Potomac River," historian David C. Holly has explained. He goes on to tell how Washington took on an unexpected role:

> *Along the river, planters, merchants, villages, towns and the steamboat companies themselves erected wharves where the steamers could dock. Washington, which no one up until then seriously considered to be a commercial port, became the hub of a steamboat trade, thriving as the postwar economy sloughed off its doldrums and adjusted to the demands of a new era.*[14]

Nor was the *Wawaset* noted for the speed that brought recognition to her sister vessel, the *Excelsior*. That ferry had double boilers and a superstructure so high that it hid the walking beam, an arrangement of moving arms that marked most steamboat silhouettes.[15] The *Wawaset* may have gained a little extra speed by having two wheels, one paddling on each side, but a single condensing engine had to drive both. The boiler was built at Chester, Pennsylvania, by Rearney Sons & Company.[16]

On that Friday morning, there would not be five hundred passengers. *Wawaset*'s official limit was fifty. No more than thirty passengers were to be admitted to cabins and twenty to steerage; the lower areas were given over to cargo and to passengers whose tickets were the least expensive. The capacity, scrolled on a framed license posted on the boat, had been issued less than five months earlier by the United States Steamboat Inspection Service (USSIS). The certificate also represented safety. To enforce the agency's regulations, inspectors had viewed and cleared for use the *Wawaset*'s two lifeboats and hundreds of cork life jackets stored in an overhead compartment for the use of passengers in an emergency. The steamer also had all of the firefighting equipment that the federal agency required, including hoses and leather buckets.

Under bureaucratic control of the Department of the Treasury, the USSIS had offices at major ports throughout the country. Safety was its mission, and that mission had been challenged. So many explosions and fires had damaged steamboats and killed hundreds of passengers in recent years that Congress had created a special commission with a $100,000

grant (2009 value: $1.8 million)[17] to study the mysteries of steamboat boiler explosions. The USSIS assigned D.D. Smith, its supervising inspector general of steamboats, to head the commission. Perhaps somewhat of a workaholic, General Smith was in western river waters this particular week on assignment for commission work.

For excursion trips, the USSIS issued special permits. The Potomac Ferry Company was deep into the entertainment business when it leased the Glymont Pavilion in the spring of 1872.[18]

The *Wawaset* frequently had been allowed to carry as many as 150 passengers—legally. That she occasionally exceeded that number was no secret along the river docks. Most captains were under pressure from their companies to find room for more than the rated capacity, and they did.

Inspectors were not around when a marine musician was shot dead at an excursion party aboard the *Wawaset*. Julius A. Krause, with several other U.S. Marine Corps Band members assigned to the Washington Barracks, went to provide music for an excursion party at Glymont on June 20, 1865. A partygoer, John Vernon, was showing off his new pistol when it "suddenly exploded," killing Krause. Vernon was tried and acquitted.[19] Strangely, the death of a second male, also named John Vernon and also involving the *Wawaset*, occurred in 1872. The steamboat was nearing

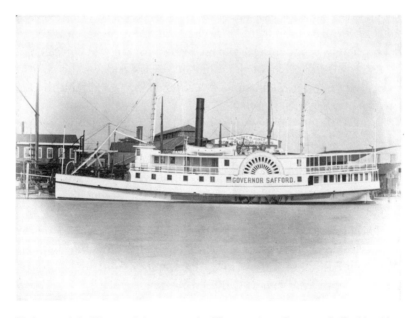

No image of the Wawaset is known to exist. The steamboat Governor Safford is said to resemble the sunken boat. Maritime Museum, Newport News, Virginia.

the Glymont landing when a group of young swimmers called for help in finding a missing twelve-year-old named John Vernon. The *Wawaset* crew failed to find the boy using a dragnet. The body was recovered the next day—seven years to the day after the Krause-Vernon shooting—and returned to Washington on the *Wawaset*.

Being at or near a drowning was a common experience for riverboats. The *Wawaset* was no exception. On June 13, 1866, the steamer was departing Washington's Fourth Street East wharf with the help of fifteen-year-old William Burch. The boy "cast loose the lines for the steamer, which had started with an excursion party," the *Evening Star* reported. "When last seen, he was fishing from the wharf." The body was recovered the next day near Poplar Point. "The lad was subject to fits," the *Star* noted, "and it is supposed fell overboard in one of those attacks."

The *Wawaset* was in excellent condition on that new August morning. The *Star* reported, "Last Spring, she was completely overhauled on the ways at Baltimore, a saloon cabin put on her upper deck aft, newly furnished and newly upholstered and painted throughout." The vessel also was given new inspection papers at the district headquarters in Baltimore. While USSIS regulations were tough, some inspectors, as this trip was to reveal, were willing to overlook deficiencies in equipment or a lack of trained crew members, as required by regulations. Also commonly known was the easy use of the bribe to obtain special permits.[20]

The *Wawaset* was more than a bus on water. Warm months found the decks crowded as urban and rural passengers alike enjoyed trips along most of the Potomac's 754 miles of tidewater shorelines. Indeed, this smart ferry had a reputation as an excursion boat. The saloon, for example, had a full-time barkeeper, Peter McKenney.

While the *Wawaset*'s firemen were below that Friday morning, seeing that the fire was building up steam in the boiler, other crew members arrived. The kitchen crew was among the first to board. Cook William Washington prepared breakfast, and Charles Tolson, the steward, set tables. McKenney, called "Doc" by some, could be a bit more casual about his arrival time. If he had washed glasses and utensils before closing the bar the previous day, he had little to do to prepare for the morning's work. It is doubtful that McKenney's saloon "carried…the special aura" that Holly saw in the Leary Line between Baltimore and Norfolk. "Their saloons and public rooms were intended to impress passengers with Old World elegance," wrote Holly.[21]

For Adeline Jenkins, it might have seemed that her work as chambermaid was never done. It was her duty to keep the passenger areas clean and

Nancy Hubbard Clark used doll's furniture to show kitchen and dining facilities aboard the model steamboat Lancaster. Photo by Jean Graham.

A model of the Lancaster, created by William Wright in 1:24 scale, is at the Steamboat Era Museum in Irvington, Virginia. Photo by Elizabeth Lee.

neat. H. Watson Wheeler, the boat's clerk, was in charge of recording the passengers coming on and going off the boat, as well as collecting fares.

Helping place and secure cargo and manage the boat's equipment during the many arrivals and departures on this trip were Henry Lewis, George Tibbs, Edward Day and Charles Jones. These deckhands also helped with cargo when the boat stopped at places with wharves. At a few of the more rural communities, departing passengers were rowed ashore. The *Wawaset* had two lifeboats. Likewise, new arrivals and light freight were boarded and rowed to the steamboat. Today's cargo included lumber stacked on an open

desk. Produce and farm animals, frequently transported by steamboat, were present also, including chickens, a bull and a couple of pigs.

The time for a steamboat to arrive at any landing was often determined by how much freight had to be loaded and unloaded. Having cargo was not unusual in the Washington area of 1873. After all, Washington was "commonly referred to by visitors as 'a country town,'" according to historian Frederick Gutheim. He wrote:

> *Most of the streets were still unpaved. The parks were unfenced, unimproved commons, or only too often dumps or borrow pits. Few shade trees had yet been planted…Flocks of geese and herds of swine were encountered foraging and rooting in the streets. An outraged Vermont senator complained in 1871 of "the infinite, abominable nuisance of cows, horses, sheep and goats running through the city.* [North of Massachusetts Avenue], *you just go across the common and you are in the country.* "[22]

The boat's clock was still far from the six o'clock departure time when the first horse-drawn carts and vans arrived and liverymen began carrying loads to the hurricane deck.[23] This main deck of the steamboat was large enough for dozens of passengers and the cargo. For this trip, perhaps it did not seem odd that some of the officers personally saw to the cargo's handling.

The captain was new to the *Wawaset*. John R. Wood had taken command at a time when the crew was demoralized by the deaths of Captain Samuel Fowke, who had served as master for many years, and his engineer son, William Fowke. Both had died earlier that spring of smallpox.[24] Wood had gone to the United States Customs House in Alexandria on May 1 and taken the "Oath of New Master" before D. Turner, the collector.

Captain Wood's corps of officers included John W.L. Boswell, pilot, who had worked on the Potomac for more than eight years; Robert W. Gravatt, mate; and a father/son team, Robert and Samuel Nash, who were chief and assistant engineers, respectively. Robert Nash was well known among river crews, having served as an engineer for twenty-six years. Arriving for their command duties, Wood and Robert Nash would have spent time checking the cargo. Some of it belonged to them, or they were acting as agents of the owners. Selling goods at downriver stops brought in extra money.

Captain Wood might have carried out the master's traditional duty that morning, welcoming passengers aboard at the Seventh Street Wharf. The first white passengers were able to claim spaces of their choice in cabins or in the steerage space below the main deck.

The Last Run of the Steamboat *Wawaset*

After working or shopping in the city, some of the passengers were heading for their homes in the small downriver communities of Virginia and Maryland. The Potomac, after lengthy disputes over the years, had been declared completely within Maryland—up to "the low tide mark" on the Virginia side. The passengers this day may have been evenly divided between Washington and Virginia, with a few from Maryland. One of the Virginians was Ephraim Nash, a farmer from Northumberland County.

Another passenger was a young mother from King George County. Alethea Garnett Gray had been in Washington City to do her "bulk shopping." "Lethy" and her husband, Cornelius Gray, had four children to care for—daughters Lou Ida, Lucy B. and Laura A., ages seven, five and two years, and the baby, George Allen, ten months old. The children were home with their father, but Mrs. Gray expected to see them soon at Chatterton's Landing in King George.

Lethy, according to family legend, was descended from Native Americans. Cornelius, the family believes, was a fugitive from slavery. Both of them were born in Caroline County, Virginia. Lethy was the daughter of Albert and Linda Garnett; Cornelius was the son of George and Lucy Gray. Lethy Garnett and Cornelius Gray grew up among wealthy white estate owners. The Garnett family owned Spy Hill through Emma Baber, who married Thomas Stuart Garnett. The Garnett family, served by Lethy's family, also owned Shirland, an estate in Westmoreland County, and when Emma Baber Garnett's husband and father died in the 1860s, she left Shirland and returned to her childhood home at Spy Hill with her servant, an ancestor of Lethy Garnett. Spy Hill has been in King George County since 1778, when King George and Westmoreland Counties exchanged boundaries. It was first a Washington estate, and then the Baber family bought it from the Washingtons.

Like many of their neighbors, the Grays undoubtedly raised most of the vegetables they needed and may have had chickens and other farm animals to provide milk and meat. Cornelius Gray had a horse and wagon for farm work and travel. But Potomac families also needed salt, sugar and flour, among other products, to feed their families, as well as dry goods, hardware and farm supplies from city stores. Once a month, Lethy took the ferry upriver to Washington, bought the goods she needed, stayed overnight and returned home on the next day's early ferry. She had made the familiar trip this time on Thursday, completed her shopping, rested overnight and now, on Friday, she was boarding the *Wawaset* to return home.

The Grays were continuing the tradition both had brought to their marriage—the unity of family—and they were forming a new

Spy Hill still lives in Virginia legend as a plantation manor. A cemetery there has unmarked graves of former slaves and other African Americans. King George County Museum, photo submitted by Bettie Lou Braden.

generation on that strength. A study of Reconstruction pointed out that after Emancipation "the family, together with the church, remained the foundation of the black community."[25] The Grays had been married about the time former slaves from Spy Hill and other plantations were founding King George County's first African American parish. The first Good Hope Baptist Church building had gone up only a year before, in 1872.

Lethy's absence from her children might have tugged at her heart a bit harder when an entire Sunday school class from Washington's Mount Vernon Place Methodist Church clambered aboard at the Seventh Street Wharf. It might have seemed that as many mothers as children were in the church group. The children's yearlong attendance was being rewarded with a summer day's excursion. The Reed family attended this church, so perhaps John Reed was an adult escort for his brother's children while his new sister-in-law was planning an overnight visit with her Walker family in King George.

Indeed, Lethy might have felt that she was the only woman without a child in her care. Everywhere she looked around the boat, she could see adults with young people. To name a few, there were Miss Belle Price, Mrs. Mahala Fleet, Mrs. Lucinda Grant, Mrs. Hesther Griffin, Mrs. Laura Rich, Miss Bertie Sanders, Ms. Fannie Taylor and Mrs. Julia Shanklin. Like John Reed, a few men were with children also. William E. Emerson was there with his daughter. George Cooke, who ran a grocery on Seventh Street, had

Good Hope Church was the first church founded for African Americans in Virginia's Northern Neck. It came complete with a water pump out front. King George County Museum.

his two sons, thirteen-year-old Leslie and a ten-year-old, apparently headed to Warsaw, Virginia, to meet the vacationing Mrs. Cooke.

It's very likely that contributing to the crowd of youngsters aboard was the Potomac Ferry Company's generous policy of not charging, and not registering as passengers, children under the age of ten.[26] But mostly, it was the weather. The *Star* speculated in its next-day issue:

> *It may seem strange that so many women and children were upon the* Wawaset…*but it seems that quite a number of families were seeking country resorts for the heated and sickly term during the present month. There were, therefore, comparatively few male passengers on board, and the females, without experience to guide them, and not knowing what to do in the emergency, were capable of little more than frantic but useless efforts to save the lives of their children.*

The *New York Times* added:

> *There has latterly been a great deal of sickness here among children, and excursions down the Potomac and short stays in the southern counties of*

Mothers with their children from Washington's Mount Vernon Place Methodist Church (pictured) boarded the Wawaset for an outing never completed. Photo by John C. Villforth.

Maryland and Eastern Virginia have become a very popular means of escape for those who cannot go further away from home; hence the large number of families whose husbands and male protectors stayed behind.

A major business highway, Seventh Street was the ideal landing place for country folks coming to the city for occasional shopping. In 1862, Congress had chartered a horse-drawn street railway from the Potomac River to Florida Avenue. Then known as Boundary Street, it was the city's northernmost boundary. For another important reason, ferry service was readily available at the Seventh Street Wharf. During the last decades of the nineteenth century, water transportation in and around Washington was handled by four companies: Inland and Seaboard Coasting Company; Clyde Line; Washington Steamboat Company, Ltd.; and Potomac Steamboat Company. The *Wawaset* was owned by the Potomac Steamboat Company.[27] How highly rated was she? The *Washington Star* was to report the day after the wreck, "She was considered the finest excursion boat ever placed upon the Potomac."

Jeanne Fogle's *A Neighborhood Guide to Washington, D.C.'s Hidden History* describes the area in the 1870s:

Running north–south, 7ᵗʰ Street, NW, connected the outlying farmland to the Center Market and beyond to the river wharves in southwest

The Last Run of the Steamboat *Wawaset*

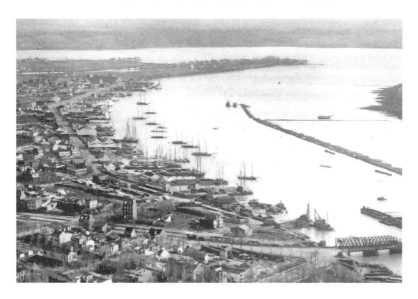

This panoramic view of Washington wharves includes the dock at Seventh Street Southwest, where Wawaset passengers boarded.

Washington...A strong German population settled along 7ᵗʰ Street beginning in the 1850s, reinforcing it as a commercial corridor...This was a neighborhood for hardworking and successful dry goods merchants and craftsmen...Italians, Greeks and African Americans also moved into the old downtown area.[28]

Even Washington storekeepers took vacation time during the summer's worst heat. Like grocer George Cooke, two typesetters at the *Morning Chronicle*—A.G. McGuiggan and George E. Dummer—were intent on enjoying their day off aboard an excursion vessel. Romance came with Daniel Lynch's party. The forty-six-year-old man had closed his tailoring shop in the Intelligencer Building on Seventh Street for a honeymoon. On August 6, two days before, he and a widow, Mrs. Annie Grant, had married. They had her two children with them for a long weekend. Lynch, as one would expect, was well dressed. With his gray hair, he wore a short beard.

For some families, this trip was a combined ferry excursion trip and a splendid way to spend a summer day away from hot city streets. Joseph W. Reed, a thirty-six-year-old Metropolitan Police Department officer, and one of his three brothers, John W. Reed, arrived as escorts for six family members. John continued with the others after Joe departed at the first stop in Alexandria, Virginia. Joe Reed worked a night shift usually, and he would

return to the family's home only a few blocks from the wharf to rest before returning to duty that day.[29]

The happy group included Joe Reed's three children from an earlier marriage, all under the age of ten. They were Sarah L. Reed, age seven; Marian, called "Manie" by the family, age five; and Joseph B. Reed, age two. Officer Reed's first wife, Rosalie, had died of scarlet fever in 1871 at the age of twenty-seven, and within a year Joe had remarried. His new wife, like his daughter, was named Sarah, but she was called Sallie. For them, there might soon be four children. Mrs. Reed was, as the saying went, "nearing confinement," although family members were to deny this description after it appeared in a newspaper.

Like the Reeds, whose roots were in Westmoreland County, Sallie was a Virginian, the former Sarah J. Walker. This day's trip would be a homecoming for Sallie. The *Alexandria Gazette* reported that she "was on her way, full of life and hope, to visit her parents in King George County, whom she had not seen since her marriage."[30] Her family still lived at the Mount Holly estate a few miles from the Chatterton's Landing stop scheduled about noon that Friday. Two other Reed family members with her were also homebound. The brothers' aunt, Mrs. Julia W. Kelly, and a niece, seventeen-year-old Elizabeth A. Reed, had been visiting at the Reed home. Young "Bettie," as she was known, lived in Washington and was taking a day off from work at Lansburgh's. Julia Kelly lived in Virginia's Westmoreland County. Now, the large group was headed to Currioman for a vacation at the Kelly home. The Reeds had a strong family connection to Westmoreland; Joe and his brothers were born there.

The Reed party was enlarged by the addition of Seventh Street neighbors. Sarah Muse and her son, Willie, who lived at the corner of G Street, were boarding the *Wawaset*, too.

Getting to Currioman was the boat's target for Friday. She was scheduled to stay overnight and return to Washington on Saturday.[31] Commuters would board and depart both up and down the river, but many of today's passengers were making an overnight holiday of the excursion trip. The Reed family was among them.

A blast of the *Wawaset*'s horn was sounded when the sixteen members of the crew were prepared. The gangplank was hauled aboard, and slowly the wheels on both sides began paddling the small floating hotel out into the stream of the mighty Potomac River.

Chapter 2

DOWN THE POTOMAC

All Virginians could feel the *Fredericksburg Ledger* editor's joy on May 26, 1865, when the paper reported:

> *We have the pleasure of announcing to our readers that a steamboat is advertised to leave Baltimore this evening at 4 o'clock for this city. She will, we are informed, run regularly once a week. The name of the vessel is the "Wonona," Captain Dawes in charge...R.W. Adams, our well-known fellow citizen, is agent at this end of the line.*[32]

Small-town residents in the twenty-first century may consider themselves thoroughly modern if they live near an interstate superhighway interchange. So it was with nineteenth-century folks and river landings. Many riverbank communities "felt the need to have a boat landing," wrote historian David Plowden, pointing to the "signs for Ferry Street in so many of our smaller towns."[33]

Not unlike the interstate highways that cross and circumvent Washington today, rivers helped form the city's boundaries and met its early transportation needs. When George Washington used his surveying and drafting skills to create the District of Washington, he worked with and around rivers. He wrote to Thomas Jefferson in 1791 that the new federal government was to purchase "all the land from Rock creek along the [Potomac] river to the eastern branch [Anacostia River] and so upward to or above the ferry."[34]

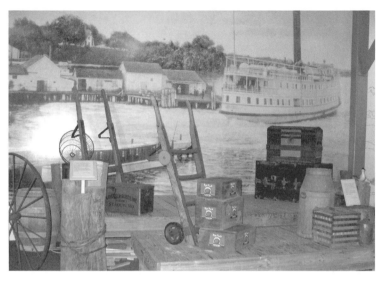

A model wharf reconstructed at the Steamboat Era Museum, with a mural. Agricultural products were shipped to area canneries, an important service to farmers. Photo by Elizabeth Lee.

The James Adams Floating Theater brought stage entertainment and offered rows of seats, as illustrated in this cutout model at the Steamboat Era Museum. Photo by Jean Graham.

The Potomac originates far north and west of Washington. Frank Graham has described the river as follows:

> *Surrounded by stone to protect its historic value, a trickle of spring water emerges from the ancient Appalachian rocks. Here at an elevation of 3,150*

The Last Run of the Steamboat *Wawaset*

feet [near Thomas, West Virginia], *the Potomac begins its journey to the sea. Three hundred eighty-three miles farther and seven miles wider, it enters Chesapeake Bay at Point Lookout.*[35]

As today's interstate highway interchanges are generally near other major roadways and high population communities, landings were located with considerations for existing conditions. Population was not one of them. Historian Paul Wilstach explains how sites were chosen: "The landings as a rule avoided the long reaches across the shallow banks to the deep channel of the river proper." The goal, then, was to permit a boat to come close to shore in deep water.[36] In many of the Potomac landings without wharves, some steamers could cruise in water that was only five feet deep near the shore. Wilstach listed thirty-two major navigable creeks opening on the Potomac—eighteen in Virginia and fourteen in Maryland.[37]

Nearest to Chesapeake Bay on the Virginia side is the Coan River, the *Wawaset*'s usual goal on her ferry schedule, but not for the August 8 cruise. On this excursion, the overnight stop would be in the Nomini Bay village of Currioman. This community was one of many along the Potomac that made a business of inviting visitors. Perhaps the best known was at Glymont, Maryland, where the pavilion was the attraction. Crowds were brought there by the *Thomas Collyer*, the *Keyport*, the *Arrow* and the *Mary Washington*, in addition to the *Wawaset*. The latter's owner, the Potomac Ferry Company, advertised in May 1872 that it had "leased from the owners this favorite excursion site." George A. Shekell, for the company, wrote: "I am putting the pavilion, dining room and grounds in thorough order and repair for the comfort, pleasure and entertainment of excursionists."[38]

Other Virginia rivers had similar runs of ports. The James River between Richmond and the confluence with the Appomattox at City Point, Petersburg, has twenty-one—eleven on the south side and ten on the north side. Excursions were seasonal on the Rappahannock River, which, with the Potomac, frames the Virginia area called the Northern Neck. In March 1873, the *Fredericksburg Ledger* announced, "The river steamers *Wenonah* and *Matilda* will resume their regular trips from this day." Like the merry-go-round, the excursion boat seemed to encourage a sense of freedom and pleasure. A *Ledger* item on June 27, 1873, informed readers, "The steamer *Matilda* left here yesterday with a merry crowd for the excursion to Tappahannock."

Steamboat excursions were not confined to southern states. As an example of northern interest, the *Brooklyn Daily Eagle*, in 1873, was carrying

31

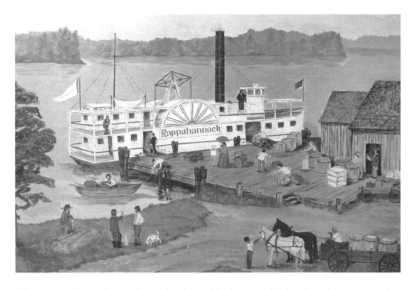

The steamer Rappahannock, on the river with the same Native American name, takes on passengers and cargo at the small-town port called Hopyard Landing, near Dogue, Virginia. This painting by artist Carrol E. Morgan was a gift marking the 1976 American bicentennial. It hangs in the King George County Courthouse. Ms. Morgan is curator at the Fredericksburg Center for the Creative Arts. King George County Museum.

advertising for the East New York & Canarsie Railroad and Rockaway Beach Steamboat Line, the steamer *Golden Gate*'s trips to Coney Island and the Harlem Steamboat trips to Astoria and other places near Manhattan.

We can guess that fear was no more a factor for 1873 steamboat travelers than it is today for airline passengers. Nineteenth-century ferries and excursion boats, however, did provide more cause for fear than today's air flights. In a thirty-nine-year period before the *Wawaset* disaster, America logged 44 collisions, 166 fires, 209 boiler explosions and 576 sinkings caused by objects in the water.[39] The list of dead passengers ran into the thousands.

Losses in Virginia and Maryland waters included the *Cygnet* in 1834, the *North Carolina* in 1859—both "burnt"—and the *Cynthia*, stranded in 1869. Frederick Tilp cites the *Paul Jones*, which burned in 1845 at an Alexandria wharf.[40] The greatest loss of life on the Potomac came with the collision, noted earlier, between the *West Point* and the *George Peabody* on August 14, 1862.[41] Seventy-six were killed off Ragged Point in the *West Point* collision, many of them wounded soldiers being carried from near

the Aquia Creek landing to Washington. Among the many major disasters with heavy loss of life elsewhere in the decade before 1873 were the *City of Madison*, at Vicksburg, 156 dead (1863); the *Brother Jonathan*, in California, 71 dead, and the *General Lyon*, in North Carolina, 400 dead (both 1865); the *Evening Star*, 247 dead (1866); and the Staten Island ferry *Westfield*, 104 dead (1871).

The worst of all was the *Sultana* disaster, which took the lives of more than 1,800 men on April 27, 1865. With the war's end, Confederate prison camps opened and Union prisoners were released to return home. They boarded the 660-ton sidewheel steamer *Sultana* at Vicksburg, Mississippi, and Helena, Arkansas, and headed north on the Mississippi River. The *Sultana* was carrying five times the legal capacity of 376 passengers.[42] After suffering in the prison camps, the soldiers were accepting of horrid conditions as they headed back to freedom. As the *Sultana* sailed north of Memphis, three of the four boilers "erupted with a volcanic fury...The shattering sound...rolled and re-echoed for minutes in the woodlands."[43]

Steam-driven trains were not setting safety examples either. S.A. Kowland records dozens of rail disasters, dating back as far as 1830. He tells of a Portsmouth & Roanoke Railroad train on August 11, 1837, near Suffolk, Virginia. Carrying nearly two hundred passengers, the train was "run into by a lumber train by which occurrence several lives were lost,

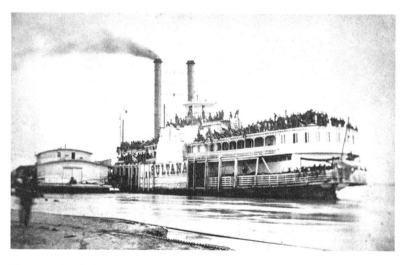

The steamship Sultana was loaded with Union troops, survivors of the Andersonville and Cahaba prison camps liberated in 1865, as it sailed north on the Mississippi River. Maritime Museum, Newport News, Virginia.

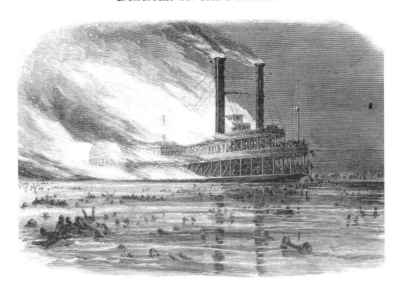

The Sultana's boilers exploded near Memphis in 1865, leading to the death of more than 1,800 in America's greatest maritime disaster. Illustration by Marion Sue Thompson. Maritime Museum, Newport News, Virginia.

The Eastern Market building on Seventh Street Southeast, Washington, opened in 1873 with eighty-five vendor stalls. It is still a popular place to buy produce, fresh meat and fish, as well as lunches. Photo by John C. Villforth.

and many were maimed and otherwise wounded." [44] As it happened, most of the passengers had been on "a party of pleasure"—a steamboat excursion—and were returning home. He tells also of an

> *explosion on the Harlaem* [sic] *Rail-Road in the city of New York, July 4, 1839…The steam was already generated to excess, but, unfortunately,*

34

the engineer neglected to blow it off. It is also supposed that water had not been taken in properly at the stopping place.

Gliding gently in the Potomac's main stream, the *Wawaset* passed downriver shores rich with shrubs and trees bordering walking paths. Poet Whitman wrote wistfully to his young friend Peter Doyle about the happy hours they spent trudging through this area, getting away from the government offices where both earned their living:

> *Pete, do you remember...those great long jovial walks we had at times for years (1866–1872) out of Washington City often moonlight nights, way to "good Hope"; or, Sundays, up and down the Potomac shores, one side or the other, sometimes ten miles at a stretch?*

He recalled, too, "those nice musk or water melons" at "the Market, corner Seventh Street and the Avenue," and his "first paralysis...in my solitary garret room."[45] Whitman was writing, always writing. He composed much of his *Letters* in this area and did not become famous until his poetry was published a few years later, during his long bout with illness in New Jersey.

On August 8, on the lazy voyage of the *Wawaset*, we can imagine the barkeeper setting up drinks for the few men able to tolerate midmorning alcoholic refreshments. Perhaps William Emerson, a great newspaper reader, chatted about the day's news. A good companion at the bar would have been Henry Hazard, a Washington man whose daughter, Nellie, was the well-known Civil War "camp angel" known as "Stella." Nellie, in her thirties by this time, wrote and performed in hospitals during the war and turned to writing well-known temperance songs—surely not a subject for popular discussion in Doc McKenney's saloon.

This was an important time in the life of the nation—the immediate years after the Civil War—and in the life of the country around the nation's capital. Being able to walk anywhere one chose was a form of freedom returned. As difficult as life was now, it was improved for most southerners over the first years of Reconstruction. Nevertheless, white and black people were still living under new terms and finding adjustments difficult. One historian has summarized that period:

> *New [state] constitutions were enacted, debts repudiated, the administrations purged, cut down and reformed, and taxation reduced to prewar levels.*

Then the new white regimes set about legislating the blacks into a lowly place in the scheme of things, while the rest of the country, having had quite enough of the South, and its blacks too, turned its attention to other things. Thus the great Civil War gave birth to a new South in which whites were first-class citizens and blacks citizens in name only. And a great silence descended for many decades.[46]

Not exactly a "silence" for all. Defining "the twelve tragic years that followed the death of Lincoln," another historian thundered:

Never have American public men in responsible positions, directing the destiny of the Nation, been so brutal, hypocritical and corrupt. The Constitution was treated as a doormat on which politicians and army officers wiped their feet after wading in the muck.[47]

Journalist John Townsend Trowbridge, touring what he called "the New South" in 1867, wrote:

There is much shallow talk about getting rid of the negroes, and of filling their places with foreigners. But war and disease have already removed more of the colored race than can be well spared; and I am confident that, for the next five or ten years, leaving the blacks where they are, the strongest tide of emigration that can be poured into the country will be insufficient to meet the increasing demand for labor...But are the lately emancipated blacks prepared for the franchise? They are...far better prepared to have a hand in making the laws by which they are to be governed than the whites are to make those laws for them.[48]

The acclaimed outreach of Americans toward full equality was being widened to include "the colored." Into these years rode the whites-only Ku Klux Klan's hooded attacks on African American citizens. Still, there were signs of hope. Washington's Metropolitan Police Department was integrated almost from its beginning in 1861, and at least one white man was dismissed for insubordination because he refused to serve with an African American officer.[49]

Thousands of new black voters joined to support a white man in Washington's mayoral race in 1868. Sayles Bowen, a fifty-five-year-old abolitionist, was the most prominent defender of equal rights in Washington City. He had served as police commissioner, tax collector and District of Columbia postmaster. Bowen appealed also to Washingtonians who feared

a proposed relocation of the nation's capital to St. Louis. He won easily, but his noisy tenure in some ways widened the black-white gap even more. While Bowen's mayoral administration was considered "notoriously corrupt," according to the *New York Times*, no one criticized his egalitarian efforts.[50] But then, Sayles Bowen's civil rights advocacy had not provided equal values in such matters as seating on steamboats.

Historian David C. Holly has described the practices of segregation:

In most vessels, second-class accommodations, to which blacks were assigned, occupied a space in the hull below the main deck, often in the stern. The area was divided—male and female, black and white—with berths, sometimes in curtained cubicles, around the edge. A few portholes gave feeble ventilation. Most steamers had a second-class lounge or saloon with chairs, a mirror or two, and some sort of adjoining washroom and toilet, all segregated by sex and color.[51]

Not many boarding the *Wawaset* in 1873 would have understood a later interpretation of the times: "Democrats with dissident Republicans gained full control of Virginia in 1873, effectively ending Reconstruction there." "Reconstruction," this account tells us, was

one of the most turbulent and controversial eras in American history… [before it] *ended in 1877…Few white southerners accepted the idea that African Americans deserved the same political rights and political opportunities as themselves.*

Indeed, "incompatible definitions of the meaning of freedom produced pervasive conflict in the cities and rural areas of the south."[52]

Lethy Gray, with her monthly shopping load, the children in the Sunday school class and other African American passengers on the *Wawaset*, "were allotted the hot bow deck section," one author has written. They were "obliged to find seats amidst the cattle, peach boxes and hen coops."[53] President Lincoln had put an end to slavery, but discrimination went on. And in this case, the back end of the steamboat would be the place of greatest danger.

The *Wawaset*'s first stop downriver came at 7:15 a.m. At Alexandria, Joseph Reed left his family in the care of his brother, John, and returned home. Joe would need sleep before reporting in uniform for duty with the

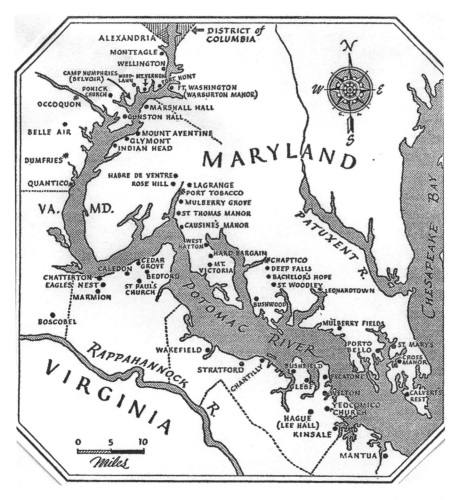

This map of the Potomac River's "Great Eastern Bend" locates Eagle's Nest and Chatterton's Landing, where the Wawaset went down. Illustration by Mitchell Jamieson. Copyright © 1949 by Holt, Rinehart and Winston.

Metropolitan Police Department that evening. At least eight passengers boarded at Alexandria: Rozier D. Beckley, a special agent in the U.S. Post Office Department who was booked to the final stop at the Coan River; Mrs. Hester Griffin with three children; Mrs. Overton Taylor with a nephew; and William Emerson with his daughter. Mrs. Griffin may have received extra attention from the boat's crew because she was the daughter of Captain Ragan of South Washington.

As the sun ran across the southeast-bound *Wawaset*'s starboard, the steamer's next stop was at a familiar and popular place: George

The Last Run of the Steamboat *Wawaset*

Washington's Mount Vernon, Virginia. Next came landings on Maryland's shores: at Liverpool Point, where Robert Olive came aboard for the trip to Longwood Wharf, and at Glymont to take on Virginia Marbury, traveling with her young cousin, Kate McPherson. Miss Marbury was on holiday from her clerk's position in the United States Treasury Department. The two young women were headed to visit their grandmother, Ann Irwin, and maternal aunt, Fannie Grymes, at Eagle's Nest, property next to Chatterton House.[54]

H. Watson Wheeler, the boat's clerk, was to recall one passenger debarking at Glymont, a man boarding at Evansport and, on the Virginia side at Smith's Point, a youth named Braxton leaving the cruise. After that, his recall worsened. He said that he had not registered every passenger, but in any case, all the records were later destroyed. The best he could remember, the newspapers reported, was that the following passengers left the boat: "two or three at Sandy Point, of whom he thinks one was a colored woman and two children; four white ladies and two or three children, and one or two white men and six colored men and women." If his information was accurate, 4 had boarded and 20 or more passengers had left the *Wawaset* before she reached the major turn near Maryland Point. That would have left slightly more than 130 travelers and the 16 crew members still aboard.

Following a zigzag pattern, crossing and recrossing the Potomac, the *Wawaset*'s passengers now faced downriver stops at Aquia Creek in Virginia and Riverside Wharf in Maryland. After a quick visit on the Maryland banks, the boat crossed the Potomac and headed upriver perhaps one mile to a point a few miles south of Aquia. The area for ten miles around Aquia Creek has pre-Revolution history roots. Captain John Smith's 1612 map indicates that many Indian settlements were in this area, notably those of the Patawomac (Potomac) tribe. The first house burned by the British fleet during the Revolution was at Aquia.[55] The region was to suffer worse. In the immediate years after the Civil War, journalist John Townsend Trowbridge took a "breezy sail of three hours" down the Potomac and found that woodlands "which densely covered all that region before the war had been cut away. Not a building of any kind was to be seen."[56]

The *Wawaset* could not pull over to the Chatterton's Landing beach because it had no wharf. Deckhands would row one of the lifeboats to the landing. Alethea Gray, Virginia Marbury and Kate McPherson would be departing there.[57] Lethy Gray knew that her husband, Cornelius, would be

among those waiting for passengers. He would have brought his horse and wagon—not a simple task in that location. The road to the landing, running west of Chatterton House, went downhill one hundred yards to the beach. The building was on a bluff fifty feet above sea level.

Virginia Marbury and her cousin would expect their aunt to be waiting. A frequent presence on the beach there was maintained by Joseph Caywood. He "rented the fishing shore" from the Chatterton's owners.[58]

The property's identity as "Chatterton" was almost as old as America itself. Peter Ashton, the original owner, was a member of the House of Burgesses for Charles City County, Maryland, in 1656 and for Virginia's Northumberland County in 1659–60, as well as Northumberland sheriff in 1658. He was probably descended from the Ashton family of Spalding, Lincolnshire, England, in turn descended from the Ashtons of Chadderton (or Chatterton) of Lancashire, England. When Ashton died about 1671, his will gave "Chatterton on the Potomac" to his brother, James Ashton of Kirby-Underwood, County Lincoln, England, and two thousand acres adjoining Chatterton to another brother, John Ashton of Lowth, Lincolnshire. Soon after, Virginia and Maryland began legislating the formation of towns through existing counties. Maryland's Assembly at St. Mary's described the intended town locations: "They shall be ports and places where all ships and vessels, trading in this province, shall unlade and put on shore, and sell, barter and traffic away."[59]

Signs, one of them with a misspelling, mark the intersection of little-used roadways near Chatterton's Landing. Photo by John C. Villforth.

The Last Run of the Steamboat *Wawaset*

This grassy lane once supported horse-wagon traffic to Chatterton's Landing. Photo by John C. Villforth.

Chatterton House sits today as it did in 1873, overlooking the landing where Wawaset passengers were headed. Photo by John C. Villforth.

Aquia had been an important location for Confederate defenses throughout the Civil War, along with batteries placed at Potomac Creek, Mathias Point and the Coan River. In the first naval engagement of the war, in May 1861, five Union gunboats failed in battle with Aquia batteries, although a year later the Union successfully overran the site in the Battle of Fredericksburg and retained it.[60] The *Wawaset* had stopped there in 1865 when in service as a hospital boat.

At Aquia and Chatterton's Landing, which are only a few miles apart on the Virginia shore, the Potomac River takes a sudden turn to the

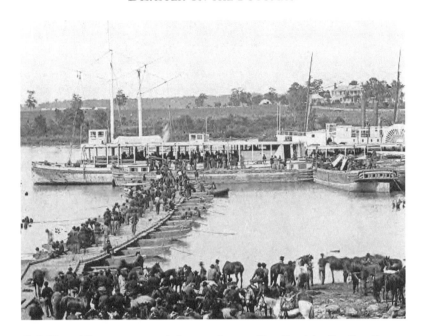

Civil War soldiers move toward the steamboat at Port Royal in Caroline County, Virginia. They also occupied Walsingham, the Port Conway manor atop the hill across the Rappahannock River in King George County. Library of Congress.

northeast. With this "Great Eastern Bend," as it has been called, everyday passengers might have felt that they had now left Washington behind and were heading for Chesapeake Bay, still more than forty miles downstream. Standing at Chatterton's Landing awaiting the arrival of their family members, Cornelius Gray and George Walker were looking toward the bend as the *Wawaset* moved closer in crossing from Maryland's Riverside Wharf. George was there to pick up his sister, Sallie Reed, returning to Mount Holly, and Cornelius would help Lethy Gray get her bulk shopping packages into his horse-drawn wagon.

For the passengers still aboard after Chatterton, Westmoreland County would be next, bringing Pattie Sandy and the Blackwells home, and then Northumberland, where Ephraim Nash would depart. Not far beyond would be Currioman, where Bertie Sanders and the large Reed family group would end the day's trip. The *Wawaset* would remain overnight in Currioman Bay near the Coan River and return with new passengers that Saturday morning.

The "bend" could serve as a kind of symbol of progress—a welcome sign, even, for travelers. The *Wawaset* never made the turn. For the people aboard, their pleasant day on the water was about to end in fiery disaster.

Chapter 3

FIRE!!!

And hour by hour, did the heavens grow pale,
The river go by to swell the tide,
And the spirits that wait on awful chance
Lift their plumes for a loftier flight?[61]
—*From "At an Old Grave," by Harriet Prescott Spofford*

It is difficult to say who exactly discovered fire spreading beyond the *Wawaset* firebox because there were so many who later told of their own startled awareness. Carrying about 150 passengers and crew, the steamer had left Riverside Wharf in Maryland and was plowing upstream as she crossed to the south shore of the Potomac River. Chatterton's Landing, off to the left, was easily in view. Very likely, the women preparing to disembark there could make out relatives waiting for them near the landing.

When the steamer's signal was sounded, the time was about 11:45 a.m. The *Wawaset* had been underway for nearly six hours. Everybody involved later reckoned that it was between 11:30 a.m. and noon. Lunch time! The cook and kitchen staff would have been preparing for that meal. "But few of the passengers were asleep, and none in the staterooms. Some were lying down on sofas," Captain Wood reported.

A blast of the steamboat signal was part of riverboat tradition. Coming and going, all boats sent their distinctive sounds to alert passengers and bystanders. Sometimes it was truly necessary; for instance, during times when a landing was fog-bound and the boat was being nudged carefully

This modern, narrow dock at Chatterton's Landing is reminiscent of the 1873 version. Photo by John C. Villforth.

toward shore. The best officers were their own pilots. Having learned through experience all of the subtle clues of tides and river depths near each of the dozens of ports, they might have considered the signal a proud announcement of their safe arrival. On a warm noontime in midsummer, the *Wawaset* had no need to use her signal as a warning.

Deckhands were getting ready for the next stop. They would be rowing passengers in a lifeboat to the shore at Chatterton's Landing. "We had the little boat down at the side, with the block and tackle attached," said Samuel Nash, the assistant engineer. Fireman Lorenzo Brown was on the hurricane deck, oiling machinery while off duty from the boiler room. The other fireman, John Forman, was moving to the fireman's room, as it was called, to get into his work "overhauls."

William E. Emerson at first sensed the fire more than saw it. Reading a Washington newspaper, he was leaning against the wheelhouse wall on the hurricane deck. The wooden planking felt "excessively hot," he was to recall. But then, "I saw wisps of smoke between the cracks of the planks." He was escorting his daughter and perhaps for a moment looked around quickly to bring the child into view.[62] He was apparently one of the few who thought to look for life preservers. Several hundred of these cork vests, more than enough for everyone on board, had been stored in a tight ceiling compartment over the gangway. Emerson was to recount his experience of wedging open the door and pulling two preservers for use by his daughter and himself. No other passengers were to find or use the

lifesaving equipment, although Emerson was to claim, "We put on our life-jackets and were ready to jump when the only other man aft tried to tear my life-jacket from me. He didn't succeed."

The steamboat's officers were carrying out their duties near the wheelhouse. John Boswell, the *Wawaset*'s pilot, was at the wheel, guiding the boat in the middle of the river, and Captain Wood was talking with Samuel Nash, who was apprenticing as assistant engineer under his father. Engineer Robert Nash had left his station below and also was near the small building atop the hurricane deck. Another passenger, Rozier Beckley, was to claim that he was the first to discover the fire. Beckley said that he was at the bar, having a second beer after the boat left Smith's Point, when "I turned to my left and discovered smoke coming from over the sheathing on the boilers. A colored man soon afterwards ran through the boat and cried 'Fire! Fire! Fire!'"

The fireman, who went on to alert the captain, was John Forman. He had at first thought that the smoke he saw was coming from the kitchen. He was to say later that "the first place he saw the fire was in the forward bow."

Orrin Eddy, a passenger from Washington, was to remember that "the smoke smelt something like lubricating oil."

Quickly surveying the scene under his command, Captain Wood said, "I immediately came out and found the flames reached quite to the hurricane deck along the walking beam." Soon after, the captain was to decide, "The fire caught in the hold, but it is impossible to tell just where. The boat was dry, almost like tinder, and the flames, when they struck the oiled machinery, spread like a torch."

He added, "The cargo was of a miscellaneous nature, and containing nothing inflammable except two barrels of whisky, which were in the forward hold." Robert Nash said that, once alerted, he "tried to get in the hold…but the smoke was so thick I could not. I then turned in a fire extinguisher and went on the forward deck and threw buckets of water on the spreading flames."

Sam Nash also rushed below, planning to check the engine room, but heavy smoke in the gangway turned him around. From that passageway Nash returned to the forward deck and used a bucket to throw water on the growing flames.

Young Kate McPherson and Virginia Marbury were in the cabin area when alerted. They groped their way through the gangway but were separated in the smoke. By the time Kate reached the main deck, Virginia had vanished. "The first thing we knew," McPherson said, "the boat was almost wholly enveloped in flames. They burst out all around us and swept aft."

Bartender Peter McKenney said that he left his workplace as soon as the cry of "fire" was heard and, rushing to the hurricane deck, "saw smoke and flames leaping from the engine room, near the walking beam."

By now it was clear that flames were destroying the entire wooden midsection of the boat. That had the effect of separating most of the passengers into two groups. Those in the back of the boat were the African Americans who had been assigned seating aft and therefore were looking out into the Potomac River. Passengers in the front, most of them white, were looking over the bow toward land.

"In less than an instant," Emerson said, "the wildest confusion prevailed. The passengers rushed to the rail, panic-stricken and frantic, and wild with fear. Very few had presence of mind sufficient to take care of themselves."

In the stern, a large group was sitting in the wooden lifeboat, waiting to be lowered to the water. They seemed to have their own destiny in hand. According to several white passengers, the African Americans in the boat would not allow white people to board. The lifeboat, the seated group declared, was "the colored people's boat," according to Kate McPherson, quoted on August 12 in the *New York Times*.

Captain Wood said:

> *I then saw that it was impossible to get to the lifeboats, which were on after-quarters on deck, to lower them, although they were full of passengers. I threw water on the wheel ropes so as to keep her steerage all right, and passed buckets of water from below to the hurricane deck for the* [same] *purpose.*

Captain Wood sustained minor burns on his neck and ears while helping throw water on the flames and, at one time, lowering a woman from the upper deck, according to Beckley.

In fact, both the *Wawaset*'s lifeboats became, in a horribly perverse way, *death*boats. The wooden boat in the stern, which the deckhands had been preparing for Chatterton's Landing, had filled quickly and was swung over the side but not lowered. As it hovered there, the passengers screamed for help. Emerson, now in the river with his life preserver, looked up to see the wooden lifeboat "hanging by the davits, full of people. Someone cut the bow rope, but not the stern. All were dumped into the river and drowned."

Another account said that a male passenger, in extreme agitation, took a knife and cut one of the ropes holding the boat over the water. The result was to send that end of the small craft downward and to pitch the passengers into the Potomac River. Many of them apparently did not know how to

swim. The *Star* reported, "Nearly all who had taken refuge in it were lost." Now the wooden lifeboat was dangling above the water and empty. Emerson watched as the lifeboat "was then lowered, and another crowd jammed in."

A number of passengers were injured and even killed when they were trampled by panicked passengers racing to the railing to jump overboard. Mrs. Overton Taylor, who had joined the trip in Alexandria, was to recall, "I was only able to jump over the railing after clearing away the broken limbs of several who had been crushed by those on top in their endeavor to get to the water." Mrs. Taylor went over the side, hand in hand with her nephew. "When we came up the first time," she said, "I told him to cling to my neck. The air bubbles in my skirt kept us afloat. After great exertion, we were able to reach the shore."

McKenney, having left the saloon, joined deckhands and passengers who were working to fight the fire. "At this time," he said, "the hose had been put in service, and they did the best they could, and the fire extinguisher was also turned on, but the flames were too fast, and buckets were then taken."

The bartender also had a comment about those who had patronized his bar: "I can vouch that the captain and crew, as well as the passengers, were perfectly sober, and I have never seen men work better, but the fire spread very quick."

Confused and panicked, passengers and crewmen everywhere were in motion. Even the cook, William Washington, was "making efforts to save the colored women," Beckley said later. He thought "there was about one hundred passengers aboard, the majority being colored, women and

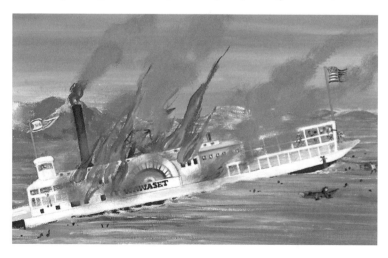

The steamboat Wawaset, a paddle wheel on each side, is consumed by flames in the Potomac River. Detail from a painting by Anne R. Dolan.

children." As part of the stampede, especially on the back decks, women took their children and jumped into the river. James Newman, awakened by shouts of alarm, said that flames prevented his attempt to go to the forward decks. "When I jumped over," he said, "I jumped into a pile of ladies. They were jumping over all the time."

The Northumberland County farmer, Ephraim Nash, moved from the bow to the stern after seeing smoke and said, "I think, on the port side of the hurricane deck, passengers could have passed from the aft forward up till the time the boat stuck." Nash jumped with a peach carton as the boat moved into shallow water.

As terror spread with the advancing flames, there was no time for officers to confer on a strategy to save lives. "Captain," said Boswell, the pilot, "the best thing we can do is to run her ashore at the nearest place, Chatterton's Landing." Wood agreed, and the last run of the steamboat *Wawaset* began with Boswell's quick adjustment to the wheel. At that point, the steamer and all of her passengers were about twelve minutes from the landing. Boswell rounded up deckhands and "kept them pouring water on the wheel ropes until the fire drove them off deck."

The captain was to explain that the boat's speed was not slowed, as it would be for a normal approach to shallow water. Time alone would be on the side of saving lives as the steamer headed upstream at the point, then as now, where the Potomac flows downstream at its maximum tidal current.[63] No worse time could arrive for the boat's officers—they were going against the tide while changing directions to run aground. And yet, that time came. In the pilothouse, Boswell and Wood were forced to leave as fire overtook the small structure. The captain said, "I remained on the hurricane deck until the flames had burned the window curtains in my room and the saloon windows below were shooting forth fiery debris." So fast had the flames spread that they had reached the back of the pilothouse, the highest level in the boat, "in less than five minutes after the alarm was given," Wood said.

As the captain and pilot prepared to save their own lives, some crew members and passengers were throwing objects to passengers already in the river. They threw loose lumber on deck—fruit boxes, chicken coops, any objects that would float. "But very few [passengers in the water] had presence of mind to avail themselves of these aids," a *Star* reporter wrote after interviewing survivors. That was not so, according to engineer Robert Nash, who did not know how to swim:

The Last Run of the Steamboat *Wawaset*

After I saw I was of no further service, I jumped overboard and clung to a peach box until rescued by my son. Many were saved by clinging to the peach boxes which were thrown overboard. The excitement was intense... When in the water, I saw a man and small child struggling. I tried to save the child by placing it on the peach box, but by some means both got away from me, and it was the last I saw of them.

Nash's son, Samuel, told of using leather buckets to throw water on the fire on the forward deck until

it grew so hot I couldn't stand on the deck, so I jumped overboard. I did not swim ashore but remained in the water to see what I could do. An old man jumped off about the same time I did, and asked me to help him. I got the peach box and gave it to him, and led him to where his feet could touch bottom. I then got a second peach box and went after my father, who was about exhausted, and took him to a safe place where he could wade ashore. Mr. Boswell and myself then got a small boat to pick up such passengers as we could. We rescued from the rudder three colored women and a colored child.

Like Robert Nash, nonswimmer Charles Tolson, the boat's steward, described his moves upon "finding it getting too hot." He said he "climbed over the stern and slid down the rudder-shaft, catching hold of the curve in the top part." He seated himself there until smoke and flames "burned him out," one reporter wrote, "and he struck out for the best he could." He touched bottom in the water "and gave a kick towards shore. He went under twice more but someone in a boat grabbed him and brought him on board." Tolson told of the spirit of survival that he witnessed on the rudder. "Six women caught hold of the chain, and were pulled off by others trying to save themselves," he said. The screams were so pitiful that they "nearly made him frantic, but he could do nothing," he told a reporter.

The *Wawaset* was headed into shore now, and the speed that was accepted as normal in the middle of the Potomac, before fire was discovered, must have seemed to have increased to anyone who, like Emerson, was in the water. Emerson continued his account of the wooden lifeboat once it was in the water and loaded with passengers: "The steamer went forward so fast the stern was torn out and this group [also] sank and drowned all her freight."

Not once, but twice, the steamer's wooden lifeboat had failed passengers and contributed to their demise. The second lifeboat, made of metal, was to be of some help. A group of passengers still on an aft deck threw that

lifeboat into the river and tried to jump into the boat while it was still tied to the moving *Wawaset.* One passenger was injured when struck by a turning paddle wheel. A few people, however, succeeded in climbing into the metal boat, and they pulled a few more passengers to safety.

Nash and Tolson both claimed to have been unconscious after escaping the fire. Tolson said, "When I jumped overboard, the steam struck me and knocked me senseless, but a boat picked me up and I recovered."

John W. Reed, who had accompanied six other relatives in a group with his brother Joseph's wife, said that he tried cautioning anxious passengers, "For God's sake, don't jump overboard. We will be aground in low water soon, and you can wade ashore." He said that "the shrieks of the women and children were enough to appall the stoutest heart…They would not heed me, but jumped excitedly into the water." He added: "If we could have got all the planks overboard, many would have been saved."

One newspaper quoted Reed as saying that he had lost a cousin who had jumped overboard. This was an error. The John Reed who had embarked with the *Wawaset* in Washington, bound for Currioman, was escorting the entire group of Reed family members. In the excitement and confusion of gathering the news, a reporter could easily have mistaken Reed's statement. John Reed, in fact, was not with a cousin but rather with a sister-in-law, a nephew, three nieces and an aunt.

One of the more pitiable stories concerned George Cooke, the grocer who had left his Washington business for two days. The newspapers reported:

> *He had two little children with him, and while he was struggling in the water making a fight for life, he was seen holding his youngest child to the surface, crying, "Oh, my God, save my baby!" It was supposed that the older child had already perished. There was a report that Mr. Cooke was subsequently seen alive on shore, but there has been nothing received to confirm the rumor, and it is probable that he and his two children all perished.*

Indeed, his death was confirmed. Two of the family had died in the water.

Not all of the deaths were from drowning. Cornelia Hobbs, described by the captain as "a beautiful young lady under the protection of Mr. McGuiggan," never made it to the railing where others were jumping into the Potomac's water. A.G. McGuiggan tried to beat out the flames that spread over her clothing but was forced by the heat to give up. As the fire killed Miss Hobbs, McGuiggan saved himself in the water.

And then the bad became worse. "All at once the engine suddenly stopped," the captain said. The cause was the shaft's falling. As the engine failed, the boat responded with a tremble, perhaps a hard shaking. Captain Wood recalled, "The passengers were under the impression that she had struck the land, and many jumped overboard where the water was quite deep." He was referring to the large group of black women and children seated aft. As the boat headed to shallow water, the view of those aft did not include the shallow water. For them, the shore had been obscured by the heavy smoke and fire that had turned the *Wawaset* into one huge flame. Facing shore, passengers on the front decks were quick to recognize the danger of leaving the boat.

The decision not to slow the speed, however, was succeeding. Even without a functioning engine, the boat continued toward shore "from the impetus gained." Wood explained, "She was running at great speed… and it was several minutes before her bow struck bottom." Boswell was able to keep the boat headed for the shore until "she struck [bottom] in five feet of water." The jolt of stopping sent Orrin Eddy, a passenger, overboard. Looking out the pilothouse window, Boswell said, he could see the wheel ropes burned and "broke in two." Losing the ropes meant losing control of steering. But once the *Wawaset* was wedged in low water, close to shore, there was nowhere to go anyway.

Some passengers seemed unable to move, despite the obvious need to leave the burning boat. "A great many were afraid to jump overboard," Wood said.

> *I assured them they were safe in jumping, as the water from the bow was not over their heads, and upon this assurance one or two made a leap, and many others, seeing that the water was shallow followed their example, and were saved. It was with difficulty I checked them jumping over in large bodies, and drowning each other during the excitement.*

Once the steamer had stopped, Captain Wood took to shouting for people onshore with boats to bring help. Thomas H. Massey, a passenger from Westmoreland County, was to testify, "The captain stood on the forward deck and hollered until he couldn't 'hollow' any longer."

The *Wawaset*'s officers stayed aboard until flames forced their departure. Others in the crew were not so fortunate. Two of them had died attempting to escape: George Tibbs, a deckhand, and Adeline Jenkins, the chambermaid. Little mention of them was made in any of the newspapers.

Although the *Wawaset* was safely beached, dozens of passengers were still fighting for their lives in the deep water offshore.

Chapter 4

Disaster on the Potomac

I magine the scene being observed by people onshore. That group would have included Sallie Reed's brother, the aunt of the two young women who had boarded at Glymont and the husband of Lethy Gray. From the north dining room windows at Eagle's Nest, on the hill overlooking the river not far from Chatterton's Landing, "the *Wawaset* could be seen running for Chatterton in a smother of smoke and flame," as one writer described it.[64] By now, all the cargo was lost.

Imagine also the sounds coming from the steamboat. A *Washington Star* reporter who interviewed survivors the next day wrote, "The air was filled with the piercing shrieks of women and children, while strong men stood aghast at the hopelessness of their situation." A bull, part of the day's cargo, was heard to sound its alarm. From all this noise came the familiar bleat of the steamboat heading into harbor. The pilot or another officer must have thought to sound an alarm to alert anyone in the *Wawaset*'s path as she ran for shore.

George Walker watched as his sister, Sallie Reed, went over the steamer's railing with all three stepchildren. He was described as "almost frantic with grief at the terrible scene." No one, it seems, observed African Americans in their distress, and no reporters told of their grief. But Cornelius Gray, no less than George Walker, was there to see his wife drown near Chatterton's Landing.

The sounds and unusual actions attracted fishermen and others. Some put out in their own small boats. Captain Wood was to tell of the

The Last Run of the Steamboat *Wawaset*

Bystanders awaiting passengers at Chatterton's Landing watch as the tragedy unfolds. Detail from a painting by Anne R. Dolan.

Onshore with horse and wagon for the return of his wife, Alethea, Cornelius Gray kneels in grief. Detail from a painting by Anne R. Dolan.

rescue of an Alexandria woman. Mrs. Overton Taylor was "crying for help from the rear of the vessel. I saw her hanging to the middle chains, and sent a boat to her rescue and saved her." Both Mrs. Taylor and "my sister's little boy" with her made it to shore.

Another news account mentioned "people on shore" helping the rescue efforts "with such appliances as they had, but they were of a very poor

character." The story continued, "The aid rendered was very unequal to the terrible extremity, especially as they could see one poor mortal after the other sink out of sight in the dark waters of the river."

Once Boswell had piloted the *Wawaset* to a halt in five feet of water, he "then jumped overboard and swam ashore with two ladies, whom I saved." Boswell apparently was a strong swimmer. He also told the following story:

I then brought out and landed six or eight passengers. I made a second trip to the boat and took in three colored women with a child who were hanging to the rudder, and landed them safely. I swam out again and made two unsuccessful attempts to rescue Officer Reed's wife, but she twisted away from me, in each instance, I presume, not knowing what she was doing through excitement. When I came back to the stern of the boat for the last time, three children—two white and one colored—were there. I tried to get at them, but the flames prevented me, and they were all burnt. I think two of them were Mr. Reed's children. I then went astern and bailed out the lifeboat and took nine dead bodies to Stuart's Wharf, four white and five colored.

Kate McPherson was helped by a passenger, Robert Adams, who had commandeered a boat near shore. She told a reporter that the rush of people toward the stern was so strong that she was carried along the deck and over the rail. In the water, she said, she went under twice, lost consciousness and was revived to find herself in the boat with Adams, headed for shore. Looking back, she said, she saw four little children drop one by one as flames spread to "the waist of the boat," to which they had been clinging.

Kate was taken to the home of Mrs. Fannie Grymes, where she and Virginia Marbury had been headed.[65] Examination turned up a slight burn on her shoulder, but Kate was more concerned about her companion's whereabouts. Virginia's body was recovered Sunday evening near Boyd's Hole, downstream from Chatterton's, by the crew of the *Pennsylvania*. Anthony Rodier, who owned the steamer, had removed the boat from her routine ferry service between Georgetown and Analostan Island to help with the downriver disaster. Virginia Marbury's body was taken to Eagle's Nest, and identification was made by jewelry with the initials "M.V.M." Without explanation, the *Star* reported, "the rings and bracelets were delivered to Mr. Tolson." That presumably referred to the steamboat's steward.

Mrs. Hesther Griffin of Alexandria had boarded with her three children. She "must have been feeding her infant child at the time of the disaster," the

The Last Run of the Steamboat *Wawaset*

Alexandria Gazette reported on August 9, "as she was found with one breast exposed. This lady and her children were drowned." By one o'clock that afternoon, a little more than an hour after the fire was discovered, the *Wawaset* had sunk, taking on water as fire destroyed the wooden structure to the waterline. Watson Wheeler, whose register of passengers and cargo lists had been destroyed, was still on duty. He tried "to collect the passengers together to get a correct list of the saved, but many were wandering about the shore, and some had started off through the country," he told a reporter. "It is not possible to arrive at the correct number lost at present."

"Some of the passengers had been taken off by neighbors attracted by smoke," bartender Peter McKenney reported. "We were all treated kindly, the people offering every assistance in their power."

Throughout the early 1870s, the Potomac was one of the busiest waterways in America. Historian Frederick Tilp notes that the Maine coal-ice business had been "firmly established" by 1872.[66] In the decade after the war, schooners were bringing stone to Washington for the many new federal and city buildings and monuments being raised. And by 1873, Potomac fisheries had recovered to prewar levels, to the extent that by 1876 a federal government task force scoured the Potomac for new fish hatchery sites.[67]

The *Express* came on the scene at four o'clock in the afternoon. That excursion steamer had been out to Piney Point and was headed back to Washington. It was too late to help the dead and dying and too early to begin transporting bodies to the city. Only McKenney managed to board the *Express*. Other vessels, however, were soon to come by to help.

By late afternoon Friday, August 8, Stuart's Wharf had become the center of action. Downstream, perhaps one mile from Chatterton's Landing, that wood plank structure was large enough to accommodate a crowd, and the water was deep enough for a steamboat to tie up. Bodies floating downstream in the Potomac, and those brought by rescuers in boats, were placed on the wharf for identification and removal by relatives. Those unaccounted for were to be taken to Washington. John Boswell, who had helped a dozen or more passengers to safety when the *Wawaset* ran aground, collected nine bodies. He said, "I remained at Stuart's Wharf and placed the bodies on the steamer *National*, which brought them to Washington."

Even as search and rescue action intensified, a legal procedure was conducted at Stuart's Wharf. The purpose of the inquest, apparently ordered

by the King George County coroner, was to determine the causes of the many deaths. The brief hearing stepped around the question of how the fire started. Unnamed jurors claimed insufficient knowledge of such matters generally and in this fire in particular. Their only judgment was to exonerate *Wawaset* officers of blame. The boat's name was misspelled in the reports as "*Wawasset*," a not uncommon error in other reports.

The *Washington Star*, in a story dated the following day, reported, "A coroner's jury was called at Stewart's [*sic*] Wharf, on the Potomac River, to investigate the heartrending accident, and rendered the following."

The following is the "official report" as recorded by the Associated Press and many newspapers:

> *We, the jury of inquest, called to view the dead bodies lost on the steamer* Wawasset *this day, and to inquire into the cause of the disaster to the said steamer, find, that not knowing the condition of the steamer, we cannot say as to the cause, but from the examination we exonerate the officers of said boat from all blame, as all the passengers saved testify that they did their duty.*
>
> *Given under our hands at Stewart's Wharf, King George's County, Va., this 8th day of August, 1873.*

Writing of the *General Slocum* disaster years later, Jerry O. Potter cited "the nation's near indifference to death" following the Civil War. He quoted a *Memphis Argus* reporter: "We have, as a people, become so accustomed to suffering of horrors during the past few years that they soon seem to lose their appalling features, and are forgotten."[68]

That was not true on the night of August 8, 1873, and for days after along the shores of the Potomac River. By light of a full moon over Washington that first night, steamboat crews were unloading bodies recovered from the *Wawaset* disaster and laying them on the Seventh Street wharf. Along the shore in King George and Westmoreland Counties over the next few days, shovels scraped shallow holes, just enough to cover drowning victims until more permanent arrangements could be made for burial. These bodies were not soon to be forgotten. Their "appalling features" would remain forever in the memory of those who had volunteered to walk the shorelines downriver from Chatterton's Landing. They were finding only the remains of human beings, their flesh eaten by dogs and crabs, according to newspaper reports.

The first nearby city to get news of the tragedy apparently was Fredericksburg. "[A] man on horseback had made his way from the scene,"

The Last Run of the Steamboat *Wawaset*

the *Post* reported in an 1892 account. "He gave no details, and only the bare fact of the burning of the vessel reached [Washington] by wire." The *Express*, returning from her excursion, had taken aboard the *Wawaset* barkeeper, Peter McKenney. He alone among the crew and passengers returned to Washington that night, and his reports were in the morning newspapers.

Both Joseph Reed and William Muse arrived early that Friday evening at the Washington wharves, seeking news of their loved ones from incoming crews. Among the first to arrive was Reed. He had seven of his family on the trip. He was followed soon after by his neighbor, Muse. A *Star* reporter recorded the scene:

> [Reed's] *agony, as he ran frantically around trying to glean rays of hope that some of his loved ones were saved was fearful to witness. Seeing a group about Mr. McKenney, the bartender on the* Wawaset, *who was giving particulars of the tragedy, he inquired, in hoarse, broken tones, "McKenney, for God's sake, can you not tell me something about my family?" McKenney replied feelingly, "Would to Heaven I could give you some encouragement, but it would be cruel to deceive you. Your family were all lost." Mr. Reed thereupon broke into a wail of despair, wringing his hands and showing such marks of hopeless agony as to bring tears to every eye. It was indeed a household wreck for Mr. Reed.*
>
> *Another distressing scene…was presented on the arrival of Mr. William Muse (a neighbor of Mr. Reed's), who had a wife and two children on the* Wawaset. *His distress was shown in a somewhat quieter form, but was almost more painful to witness from the convulsive workings of his face in his attempts to subdue violent expressions of grief, and from the silent tears running down his face, and his almost inarticulate attempts to frame words of inquiry.*

The *Georgiana* pulled into Alexandria later Saturday morning, bringing two passengers who had lost their children, Mrs. Mahala Fleet and Mrs. Julia Shanklin, and a deckhand, Henry Lewis. Soon after, the ferryboat *City of Washington* arrived in Washington with three passengers with burns: Hiram and Mary Blackwell of Westmoreland County and Susan Parker.

The *Charlotte Vanderbilt* patrolled a fifteen-mile oval, staying as close to the Maryland and Virginia shores as her eight-foot draft permitted, and recovered five bodies. One of them was deckhand George Tibbs. There was no word on the outcome of Joseph Caywood's efforts, but he rigged his fishing seine for human bodies.

A *Star* reporter experienced firsthand the sad efforts underway at Chatterton's. He first explored the wreck with an oarsman in a rented boat

at high tide on Sunday and then went to the shore. "Just below us," he wrote, he watched the retrieval of two bodies. "Their faces and ears were completely eaten off by crabs, leaving the teeth and bones of the face clean." One body had a silver watch with a gold-plated chain in the watch pocket of linen pants. He was identified by a notebook he carried as Rhoda Rice of Washington.

The reporter gave a detailed picture of the action around Chatterton's Landing that day:

> *While sitting on a log of driftwood, where Mr. Lautrup was engaged in sketching the wreck, the body of a colored boy drifted ashore nearby, and was dragged out on the sand. By this time, the shore was dotted for miles with people watching for bodies afloat, and all the row- and sailboats available were manned and put out to pick them up. The wind freshened, making the water rough, which had the tendency to bring up the bodies, and for hours the boats were incessantly occupied in grabbing them and towing them in between Boyd's Hole and Chatterton. The shore was lined with pieces of the wreck, among other things many peach boxes and hen coops, and halfway between the points named was the ill-fated lifeboat with the entire stern out…During the morning, five more bodies of colored women were caught and towed in, and the stench from all these corpses, after the sun beamed out hot, was intolerable.*

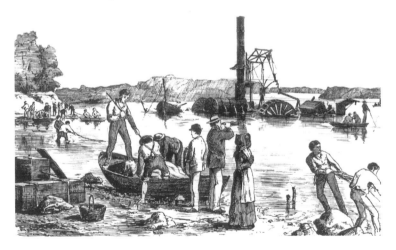

The Daily Graphic published this "general view of the wreck," under the title "Dredging for the Dead," at the scene of the Wawaset's sinking. This "sketch," the New York newspaper wrote, was "made on Sunday [two days after the steamboat's disaster] by Mr. Lautrup, our special art correspondent in Washington." Library of Congress.

The Last Run of the Steamboat *Wawaset*

Row houses like these, pictured in 2009, existed near Seventh Street Southeast in Washington in 1873. The Joseph Reed family occupied one, perhaps not unlike that at left, where march composer-bandmaster John Philip Sousa was born. Photo by John C. Villforth.

The loss of so many Seventh Street family members attracted great interest. The *Morning Chronicle*, which covered the story in what some readers considered a "more romantic" tone, cited on August 12:

> *The house of Policeman Reed, on 7th street, near the ferry wharf, a cosy comfortable little cottage from which on Friday morning last his joyous family slammed the front gate in anticipation of a pleasant sojourn in Virginia, and where last night, in an ice box, reposed for burial, his interesting little daughter, the last of the household. Truly, the umbrageous foliage surrounding his home was the canopy of death, and the fact seemed fully appreciated by the countless number of sorrowing friends of both sexes who, when he was bereft of all, sought to comfort and reconcile him to the dread visitation.*

A major new problem cropped up when a badly disfigured corpse was identified as being two different women. A "Mrs. Cobaugh" thought that she recognized her sister and her niece, Mrs. Cora Walker and Miss Julianna Willis, who lived at Eighth and I Streets. "The sobs and lamentations of Mrs. Cobaugh could be heard for some distance, and finally she was persuaded by her husband to be led away," the *Star* reported.

> *About this time, several ladies from South Washington came in and recognized the body which Mrs. Cobaugh had just before thought to be that*

of her sister as that of Mrs. Pattie Sandy of Westmoreland County, who had been visiting friends in this city.

As it developed, all three of the women were to be confirmed among the dead.

More typical of the lack of authoritative information than careless reporting were the contradictory reports on the number of bodies identified and unidentified. In one account, the steamer *Vanderbilt* arrived in Washington on Sunday night with six more bodies, bringing the total to fifty-six, "though not over twenty have been identified." The Monday *Chronicle* reported: "The body of Mr. Cooke, the grocer, was upon its arrival taken in charge by a committee of Harmony Lodge, No. 21, Knights of Pythias, the committee having gone downriver on the *Vanderbilt* for the purpose of recovering it."

The crowd at the Seventh Street Wharf grew amid a certain festive air. The *Morning Chronicle* described "Italian musicians" arriving to take advantage of the large number of curiosity-seekers. The stern-wheel steamer *National*, under Captain Cregg, brought the bodies of five women and five children. The only white child was the son of Joseph Reed. Joe's brother John had returned on the steamer with his nephew and the body of their aunt, Mrs. Julia Kelly. Among the women was the Reed family's Washington neighbor, Sarah Muse. Her family was also to lose their son Willie. "Three of the white women and all four colored infants were not recognized," the newspapers related. Much recognition, however, was given "the little boy Joseph Reed" in the Sunday *Chronicle*: "He lay, white as a piece of marble, beside his aunt Julia, with his little hands folded over his breast, and his white uncovered legs, from his ruffled linen drawers at his knees down to his yellow leather shoes, were crossed as naturally as in life. His appearance extorted many a tear from the strong men standing near his corpse."

Another newspaper recorded that a temporary morgue had been set up on the Seventh Street wharf, and "the bodies that had reached here had all been identified by friends...Undertakers' wagons were busy during the day in conveying them thence to the homes of their friends."

This was not the worst news. That came from the Virginia shores of the Potomac, where "the plundering and robbing of the dead by stragglers along the shore" had turned an ugly situation into criminal contempt and theft.

The *Ledger* also carried a story without attribution or the names of the brother and sister it mentions, which easily could have been invented. In a time when news accounts did not carry bylines, no one could be considered blameworthy if a rumor were to be presented as fact. The article is presented

here to illustrate not only the potential for fiction but also the florid and formal language commonly used in newspapers of the 1870s:

> *An episode of the disaster occurred on the steamer* Columbia *Sunday. A gentleman saved from the burning vessel, who had given his sister up for lost, took passage on the* Columbia *Sunday evening at a point below Chatterton. At another landing, above Chatterton, a lady, who mourned a brother lost in the catastrophe, came on board, both bound for Washington. Mourning soon changed into joy and thankfulness, and each saw the other as one risen from the dead.*

Virginia's harvest of death continued that Sunday, in the third day of the *Wawaset* tragedy. The body of a woman, estimated to be in her early twenties, "was seen to rise suddenly about one hundred yards from shore," one account noted. She was identifiable in two ways. One was by her hair, "fully half of her length coming above the water and then falling immediately back. It was floating off with the tide when a boat was sent out and the body brought in." She might have been identified also by the eight dollars and sixty-six cents in her pocketbook.

On Monday, "all that remains to mark the scene of the late steamboat disaster is the iron-work of the steamer, consisting of the smokestack, walking beam and framework of the paddlewheels, burned to a whitish tint, resting on the bottom," the *Ledger* reported. "The shaft seems to have either bent or broke in the middle, the wheels are careened out on each side. Nothing combustible remains. At low tide, the bottom of the hull is perfectly visible." A *Star* reporter gave the location as 250 yards below the landing and probably 150 from the shore: "[A]ll the metallic portion seem to rest firmly upon the bottom and all the machinery is exposed to view at low water...and the ironwork is burned to a whitish tint."

The bodies recovered along the shore at Chatterton's—as many as thirty—were placed in shallow graves scooped in the sand and then covered. These "graves of the unrecognized victims made up a graveyard of considerable dimensions," a newspaper reported. The claim that this was "the Wawaset Cemetery" seems to have lasted only for a few years. There is no such place in present-day King George County. The bodies located on shore were buried, most of them temporarily. The tugboat *Mary Lewis* "ran regularly for weeks" between this area and Washington, moving bodies to their permanent resting place.

Chapter 5

The Body Count Continues

By Tuesday, August 12, the count of recovered bodies had reached seventy-two. A detailed description of what was found on the body of the honeymooning tailor, Daniel Lynch, was helpful in identifying him: "plain gold ring, nine dollars cash, briarwood pipe with smoking tobacco, vial of medicine, leather bag with two keys." There was no question this was Lynch, however, when the description added: "On one foot was a boot and the other foot was bare, having the appearance of a sore on it." The next day, a "well-known businessman of this city" called the *Star* office "to say that the friends and acquaintances of Daniel Lynch...are certain it was his body recovered and buried" near Chatterton's Landing. The reason they were certain, the caller said, was that "the sore on his foot was caused by a hurt received last week while helping a young man to remove a portable printing press in one of the rooms of the Intelligencer Building."

The generosity and honesty of Lynch was illustrated with his friends' report that the day before Lynch had "called on Mr. Downman, real estate agent, and paid his rent before leaving on his trip."

Editorial pages were growling now in denouncing the Potomac Ferry Company. One writer declared, "There is a general feeling in the community that there should be a more searching enquiry into the causes that led to the *Wawaset* tragedy than was made by the King George [inquest jury on August 8]." One opinion piece claimed that the deaths of "sixty or seventy...within a few yards of shore on a calm river shows something radically wrong in

the management of a vessel to which so many lives were entrusted." Another noted, "There should have been some officer on the boat having the nerve and discretion to stand, pistol in hand, by the lifeboats and see that they were properly lowered, and that the helpless women and children were first put ashore."

The outcry for an investigation had been heard and the Treasury Department had ordered the Steamship Inspection Service to conduct a hearing. No one, it seems, had accepted the quick inquest of August 8,

The Chronicle, a journal for "the insurance fraternity," ran this drawing in August 1873 over the title "The Fire-Fiend." Nearby was a column denouncing "carelessness" in steamboat boiler rooms.

and exoneration of the steamer's officers, as the final answer. The general subject of discussion may well have turned by then to how the same officers were carrying out their official duties. An anonymous writer claimed, in a letter to the *Washington Republican*, that some of the *Wawaset*'s crew had a conflict of interest. He wrote:

> From personal knowledge, also known to a majority of the produce dealers in this city, the engineer, barkeeper and mate are in partnership, purchasing poultry and country produce generally. The very moment the steamer is made fast, the above are first at the gangway, waiting for the poor people to pass in their truck for just what they can get. Thus, leaving stations unguarded. Now, don't you think that with the above-mentioned officials at the bow gangway and the fireman also sitting out front, as will be proved before the Government commission, a hot coal could have fallen over the water pan on

the floor, which is saturated with oil, thus setting fire immediately around the boiler, where it was first discovered?

Others raised the question of officers working in the saloon. One survivor was quoted as saying that the engineer was behind the bar, and another said that the captain also was seen serving drinks. Beachcombers stealing valuable possessions from drowning victims also attracted editorial fire. The following is a sample from the *Evening Gazette* of Port Jervis, New York:

A gentleman who has just returned from the scene of the recent Wawaset *disaster reports that the steamboat authorities are responsible for disgraceful actions connected with the recovery and disposition of the bodies. As fast as a body is recovered there is a scramble on the part of many to discover whether there are any valuables or money on it, and if so, there is struggle and frequently a fight for the possession of the plunder. A large number of the bodies recovered lie along the river shores without so much as an ordinary pine box for a coffin, and with only a few inches of dirt to cover them. The result of this has been that several bodies have been dug up and partly consumed by dogs, and continue to remain exposed without proper burial. The friends and relatives of persons lost on the* Wawaset *are quite bitter in their condemnation of the Potomac Ferry Company for the heartlessness displayed by some of their workmen engaged in searching for the bodies.*

Not all the men hired by the ferry owner were eager to remove items from the dead. While boaters near King George continued to bring bodies to the shore, the superstitious custom of not touching corpses came into focus. A newspaper reporter wrote the following account:

At the interment of corpses, Colonel Lewis,[69] *a neighboring farmer, was present and hailed a colored man named Dan, who was looking on while the men were at work digging graves. Dan came up and Colonel Lewis asked him why he did not jump in and assist in burying his own color. Dan shrugged his shoulders and replied, "I can't get up the heart to do it." Said Colonel Lewis, "You mean that you are afraid to work?" "No," said Dan, "I never should have any more luck if I should touch one of them poor corpses." It appears to be the general belief among the colored people in this section that bad luck will follow them if they touch a dead person.*

The Last Run of the Steamboat *Wawaset*

The "culture of death" is the subject of a study by Mark S. Schantz. He considers the role of slavery in affecting how African Americans viewed death. In his book, *Awaiting the Heavenly Country*, Schantz wrote: "The institution of slavery may be seen as complicating and intensifying the culture of death of antebellum African Americans." He notes that slavery was regarded as living death, and echoing Patrick Henry's famous lines, slavery might have left a slave with a choice only between "liberty or death." Schantz concludes, "My reading of the evidence sustains the old cliché that death is the great equalizer among human beings."[70]

Newspapers and magazines throughout the eastern half of the nation reported details of the disaster on the Potomac. *Harper's Magazine* for October included a paragraph in the "Editor's Historical Record," along with disasters in Baltimore; Norfolk, Virginia; Portland, Oregon; Portland, Maine; India; Quebec; and Ireland. Compared to some of those events, the Potomac fire was heavy in loss of life but small in monetary damage. The *Wawaset* was insured for $28,000 of her $40,000 value (2009 value: $720,000). The Oregon fire consumed twenty-three blocks of the city with an estimated loss of $1.5 million (2009 value: $27 million). But the deaths in the other events were generally fewer than ten.

Local newspapers far from the scene placed the Potomac story on the front page. *Every Evening*, published in Wilmington, Delaware, carried a front-page story on August 12 about "The Potomac Disaster." "White and colored stragglers on shore plunder the clothing of the dead as they are washed ashore," the story reported. In Oswego, New York, the August 13 *Daily Times* front page headlined with the *Wawaset* disaster, along with "Brigham Young's Divorce Suit," "Sioux Depredating on the Frontier" and "Maine and Maryland Democratic Conventions." The language used for readers beyond the Potomac was occasionally inflammatory. A Sunday, August 10, "special dispatch" told Oswego readers that "a stalwart negro, crazy with fright, jumped in [a lifeboat] and drawing a big knife recklessly cut the stern ropes...This act alone caused a greater loss of life than any other feature of the disaster." A reader might wonder what information the reporter had to support the use of the words "stalwart," "crazy" and "big," as well as how a reporter would know which "features" caused more or less relative loss of life.

Journalists were attracted to King George County for a week or two, and local funerals were covered more than they might have been in normal circumstances. The disaster's first days put the story on front pages, but as always happens, it soon became a local story and was moved inside the papers. Two dailies—the *Washington Star* and the *New York Times*—along with the

Associated Press, appear to have been most consistent and comprehensive in their coverage. Washington's *Morning Chronicle* quickly moved the story onto back pages. In a time before print journalists' names appeared in bylines, and long before broadcast reporters came into being, this was a story that burst onto the news stage but soon was overshadowed by other disasters and deeds around the world. Public focus on the *Wawaset* story soon turned to Washington—for a few days, while steamers brought bodies to the city, and then to the federal hearings to determine what had gone wrong.

The *Times* wrung its hands over the scene that Sunday and accurately prophesied a move by government:

> *The panic-stricken passengers were helpless, as women and children always are…It seems probable that this calamity will attract attention to the general condition of passenger steamers on the Potomac River. There are several steamers which are engaged as excursion boats to different points on the river, and it may be said that they all need overhauling, both in the matter of equipment and discipline. There are no restrictions as to the sales of liquors, and officers themselves have occasionally been known to be drunk. It is supposed that an investigation into the causes of the disaster will follow.*

The *Times* had supposed correctly. The next day's issue reported:

> *The Treasury Department will make an investigation into the burning of the* Wawaset. *The Virginia local authorities who held the inquest at Chatterton's Landing exonerated the Captain and crew upon the evidence of the survivors…It appears that the inspection certificate of that vessel allowed her to carry only fifty passengers on her regular trips, thirty in the first cabin and twenty on deck. This was one of her regular trips, and it is believed that there were fully one hundred thirty persons on board.*

The first funeral given wide coverage was for four members of the Reed family. The bodies of Mrs. Julia Kelly, the Reed brothers' aunt; Bettie Reed, their niece; and Joe's daughter, Sarah, and son, Joseph, had arrived in Washington, and the burials took place on Saturday, August 9. An August 10 news service dispatch had details: "The funeral…was attended by a very large number of people. At the church, many were unable to obtain admission. There were three hearses, in which the bodies were conveyed to the cemetery."

The Reeds' burial was at Congressional Cemetery. This area was created in 1807, before successful use of an embalming procedure would permit corpses

The Last Run of the Steamboat *Wawaset*

Five linked headstones mark the graves at Washington's Congressional Cemetery of the Joseph Reed family killed in the August 8, 1873 disaster. Photo by John C. Villforth.

to retain their identities long enough for travel. Many members of Congress and other officials who died in Washington could not be returned to their home states, so this became their final place of rest.[71] The news reporter added: "Other funerals of victims of the disaster took place this afternoon." These referred to African Americans laid to rest in the potter's field on the other side of a fence surrounding the Congressional Cemetery, on a lot where a jail now stands.

Joe Reed's unhappy searching was to go on for days. Because Joe's wife and daughter Marian had still not been located, Joe's brother, Robert Reed, and cousin, William Reed, had gone to Virginia to help John Reed in the search. That Sunday evening, soon after the Washington funeral, Joe Reed had left to join his brothers at King George. He had been given free use of the tug *Johnson Brothers* and her crew, headed by Captain Cornelius Johnson.

Upon arrival at Chatterton's Landing about six o'clock Monday morning, Joe Reed was greeted by Robert. It fell on him to inform Joe that the body of his wife had been recovered. Ironically, Sarah Reed's demise had come unexpectedly not far from her childhood home near present-day Route 218, east of the Stafford County line. Identification had been made on the beach on Sunday by Robert Reed and Sarah's brother, George Walker, who recognized "her dress and some peculiarities about the teeth." Mrs. Reed was taken to Mount Holly, the home of her father, Alexander S. Walker, five miles from Chatterton's Landing. Burial took place within hours of Joe's arrival with the Reverend Thomas Henry Boggs of the Trinity

Methodist Church in King George officiating. A temporary burial was held at Hollywood Cemetery, just over the line in Stafford County.

Still missing was Marian ("Manie") Reed, the five-year-old daughter of Joseph Reed. A story written by a *Star* reporter on the scene with Manie's uncle, John Reed, told of a heartbreaking discovery:

> *Just north of Chatterton Landing we found a grave where, we were informed, were buried two children, a white boy and girl. From the description given of the girl, Mr. Reed, one of our party, thought it must be his little niece, daughter of Policeman Reed, and later in the day the children were uncovered, but Mr. Reed failed to recognize her, and the little children were covered over again.*

On that busy Monday, August 11, "on returning to the scene of the disaster" after the burial of his wife, the *Star* reported,

> *the afflicted father learned that Captain Johnson, who had been steaming back and forth* [in the tugboat] *from the point of the disaster to a few miles below, had about daylight* [August 11] *picked up a body answering the description of little Manie Reed, and shortly afterwards he picked up the body of a large, portly colored woman. The latter body Captain Johnson landed and it was buried; but so certain was he that the child was the remaining lost little one of the Reed family that, notwithstanding those on the beach clamored for it for burial, he refused to land it.*

Joe Reed, his brother John and probably brother Robert identified Manie, and they left Virginia before three o'clock that afternoon.

Meanwhile, the wharves in Washington, which were attracting the curious only when boats arrived from the King George area, were covered with a large gathering at Seventh Street on the strength of a rumor that the bodies of Sarah Walker Reed and the last of the family's children were expected that evening. The *Evening Star* reported:

> *The waiting crowd at the wharf rapidly increased as the sun neared the horizon. About 6:40 o'clock p.m., the tug* Johnson Brothers, *with her colors at half mast, made fast to the wharf, and the body of little Marian (Manie) Reed, the second daughter, enclosed in an icebox, was brought off the boat and carried to the residence of the afflicted father, who came up from the scene of the disaster with the remains.*

The Last Run of the Steamboat *Wawaset*

The funeral of the five-year-old Marian Reed was to take place at three o'clock the next afternoon from the Reed family home on Seventh Street with burial to follow at Congressional Cemetery. In the one hundred hours since Joe Reed had seen his family off on a holiday, six of them had come home to be buried. Only his brother John had survived.

The Reed and Lynch funerals must have attracted hundreds of friends and colleagues. Both were active members in the community. Besides Joe Reed's position with the police, his brother Bushrod Reed was a former captain in the Metropolitan Police Department now serving as secretary to the Board of Police Commissioners. The police would have sent a large delegation. Arrangements for Lynch were sponsored by two groups in which the late tailor held membership, the Tailors Association and St. Patrick's Temperance Society. Both organizations would have been well represented.

Daniel Lynch's Catholic funeral on August 14 included burial at Mt. Olivet Cemetery in Washington. His "much decomposed body, [with] a crucifix in India ink and colors distinctly visible on his left arm," was placed in "a very costly burial casket." Lynch's death had attracted special attention because he was on his honeymoon when he, his new wife and the woman's two children all died.

Romance was also given as the cause for the apparent suicide of young John Brown. A shoemaker in partnership with William Gilmore on New York Avenue, the *Star* reported that Brown was "greatly attached" to a young woman killed in the Potomac steamer disaster. Learning of her death, Brown, on Monday, August 11, gave Gilmore his shop keys, watch and pocketbook and, sobbing, left. Gilmore said that he asked no questions but assumed that Brown was leaving for Virginia and the funeral. That Friday, the only word of Brown's whereabouts came from an observer who said that he saw Brown—easily identified because of the loss of a leg—"on the Virginia side of the river walking along the road from the Long Bridge towards the brick yards. He was in such low spirits that his friends fear he has committed suicide."

Drawn by horses, hearses continued on Washington area streets. On August 15, "a large assemblage of mournful friends" attended services for Henry H. Hazard Sr. at the Christian Church, with the Reverend J.G. Butler, pastor of the Memorial Lutheran Church. A fine walnut coffin, "handsomely decorated and covered with a beautiful wreath of flowers," was lowered into a grave at the Congressional Cemetery.

Patty Sandy's funeral service was at the Baptist church in Alexandria the following day.

The parade of bodies returning to the capital area went on throughout the week. Both of the *Wawaset*'s lifeboats, "one of them stove out at the stern," were returned to Washington. That Monday evening about ten o'clock, the tug *Mary Lewis* arrived in Washington with the Reeds' neighbor, ten-year-old Willie Muse. The boat had stopped first in Alexandria to deliver the bodies of two children, a son and daughter of Mr. and Mrs. Griffin. Hester Griffin's body had been returned on Saturday, and burial took place on Sunday in Alexandria at a service conducted by the Reverend Mr. Beyer of the Methodist-Episcopal Church. Also delivered was "a colored woman whose body was disfigured beyond identification. The latter was taken in charge by Burgdorf, the undertaker," the *Star* reported.

It appears that as many as thirty-two bodies were never identified and were buried either in King George County or in Washington. The Potomac Ferry Company, the *Wawaset*'s owner, made a major move to provide help by buying caskets and paying for the burials of the unidentified.

The *Star* story on August 12 continued:

> The tug Mary Lewis *left again this morning for the scene of the disaster, and will return this evening. The ferry company intend* [sic] *to send down— perhaps tomorrow—coffins for the bodies temporarily interred, and will likely bury all permanently near the scene of the disaster not claimed by relatives.*

The tug arrived at King George on August 14 with "a sufficient number of coffins to meet the wants of Mr. McClelland's corps of men employed in exhuming the bodies of the victims of the *Wawaset* disaster and reinterring them."[72] After delivering the caskets, the *Mary Lewis* returned from Chatterton's Landing with the body of Matilda Haney. A Galilean Fisherman committee took charge for a funeral.

The number of dead was climbing beyond forty, then fifty and sixty. Recovery of three bodies "near the Maryland shore" brought the total to seventy-two, the *Star* reported. The *Morning Chronicle* was to count "eighty-two dead." Local newspapers were helping to encourage identification by running details about those still without names. The *Star*'s account on August 12, which described nineteen bodies, all African Americans, actually named one woman and one man:

> *The following is an additional descriptive list of unknown bodies found and buried by Mr. C.G. McClelland, commencing where our sad record of yesterday left off:*

The Last Run of the Steamboat *Wawaset*

Colored Females—1. Red and white calico body and gaiter shoes. 2. Supposed to be about 25 years of age, and having nine rings on the left hand. 3. Light purple calico dress. 4. Red skirt and striped. 5. Child, about 6 years of age, calico dress and gaiters. 6. Girl, about 13 years of age, striped calico dress and purple basque. 7. Supposed about 30 years of age, black striped dress, light calico apron, plain ring on right hand; thought to be Fannie Taylor.[73] 8. Black skirt and striped calico basque; one plain ring on left little finger. One also on the right hand, with square seal. 9. Yellow calico dress, overskirt trimmed with black. 10. Calico dress, brown stripes, with white buttons down the front. 11. Supposed to be about 35 years of age; black skirt and black and white basque. 12. Supposed to be about 20 years of age; red skirt, striped body. 13. Black dress, light calico apron, ring on middle finger of right hand.

Colored Males—1. Black cloth coat, gray pants, hair mixed with gray. 2. Gray coat, blue cloth vest, with brass buttons, and silver watch in the pocket. 3. Black cloth coat and pants and vest, and calfskin boots. 4. Black cloth pants and white linen jacket. 5. Black cassimere pants and vest, and linen coat. 6. Identified as Simon Bland.

The *Star* was also faithful in recording victims' relocations:

The following is a description of the bodies disinterred yesterday and removed for reburial to the spot selected on higher ground: Grave No. 8, colored man, dark gray pants with red stripe, gray coat, white shirt, and gaiter shoes; grave No. 9, colored woman, dark buff dress, with trimmings, and cloth gaiters; grave No. 12, a colored woman, with red dress, black silk ruffle, calico body with red stripe, and foxed gaiters.

The news story added: "The work of burial at Chatterton will probably be finished today [August 15]."

In contrast to this detailed reportage, newspapers reported the names of Washington residents whose bodies were returned on steamers, but the names of Virginia and Maryland residents recovered for local burials were seldom mentioned.

Chapter 6

WHAT WENT WRONG?

One of the mysteries that has remained in the case of the *Wawaset* disaster concerns the inquest conducted on the day of the tragedy and long before all passengers had been accounted for. An inquest has been traditionally an investigation ordered by a political entity's coroner or medical examiner for the purpose of determining what caused the deaths under investigation. In this case, drowning and burning would have been the leading causes; perhaps a few cases of asphyxiation or even battering, a trampling caused by a horde of panicked passengers running to one place in an escape route. This inquest, however, seemed to focus only on how the boat's officers had carried out their responsibilities to the passengers. Mid-2009 searches in 1873 county and state records of Virginia and Maryland failed to locate any official report of this inquest. Who ordered the hearing and selected the jurors is nowhere apparent. This legal procedure must have occurred, however. All regional newspapers carried an account.

But the August 8 local inquest had failed to provide answers to the public's questions, and within a week newspaper editorialists and letter writers were demanding federal action against the *Wawaset* owners and officers. If there was anyone supporting the local inquest's findings, they were keeping quiet. Newspapers in 1873, no less than today's, were often active in examining issues not familiar to all readers. On August 12, the *New York Times* raised questions about the steamboat owner's adherence to federal regulations. "It appears," a front-page story reported,

The Last Run of the Steamboat *Wawaset*

This drawing in the Daily Graphic of New York on August 12, 1873, carried the caption, "Peace hath her slaughters as well as war—a cartoon on the Potomac disaster." Library of Congress.

the owners of the Wawaset *failed to ask or receive a special permit to carry more passengers than her certificate of inspection allowed…and the penalty is a fine of $10 per passenger, and to refund the passage money. It is stated that the owners will also be prosecuted for carrying excursionists without a license.*

The more intriguing question, however, was: what went wrong? After the steamer had been abandoned and the crew had time to share information, there was some agreement on where the fire originated. A newspaper quoted Captain Wood as believing that sparks had escaped from the firebox and went into the hold aft. Engineer Robert Nash agreed with the fireman's conclusion that fire had originated "in the back smokebox for some unknown cause." Others thought that the fire had started midship. In a story that covered the front page in the *Washington Star* on August 9, the news team wrote that fire had begun

in the boiler room below, about the machinery, and that in two or three minutes all about midship was on fire, the flames bursting up through the decks and gangway, thus cutting off all communication between the bow and aft parts of the boat…As the windows and doors were all open, the draft was intense, and the doomed boat was soon a sheet of flames.

Asked how rapidly the fire had grown, Engineer Nash estimated that the time from discovery until fire had destroyed the main deck to the water's edge took "less time than I can give you my statement."

"In less than twenty-five minutes from the time the fire broke out," a reporter wrote, "the steamer was destroyed." And so were the lives of hundreds of Potomac River families.

Norman Wiard, "the well-known engineer," sent a letter that appeared in several periodicals placing blame for the *Wawaset* fire on "superheated steam." That led the *Brooklyn Daily Eagle* to editorialize on August 13, noting the King George County inquest results and how the federal hearing would turn out:

> *When a captain and a subordinate or two come forward at an inquest in a meek and contrite spirit, and say they don't know how it all happened, and they wouldn't have had it so for any money, sir, theories of superheated steam or any other will hardly disturb the inevitable verdict of "no one to blame."*

The *Philadelphia Ledger* broadened the inquiry to include compliance with regulations and overworked steamboat crews. "Are the passenger boats plying on all our rivers equipped as the law directs?" the newspaper editorialized. "Are those to whom their management is left fit persons? Or, do they have to perform too many duties, or any extra duties inconsistent with the safety of the crowds of passengers they frequently carry?"

More broadening of responsibility came from one of the nation's major business publications, the *Chronicle*. An insurance industry journal, the periodical brought its thinking to the public in a rambling column:

> *One great enemy is carelessness. That accidents do occur, which no human foresight could prevent, is no doubt true. They are, however, comparatively rare. The public is convinced that a reasonable amount of care on the destruction of the steamer Wawaset we have to go a little further back, but only to blame the builders for carelessness of construction, and the officers for neglecting to put the life-saving apparatus where it could be available. Our steamboats are so constructed that once they take fire in their upper works there is scarcely a chance of saving them; and this is true not only of the Wawaset but of the Dirigo, the Montreal and the Carlotta, burned in Portland. Their light, exposed wooden saloons are like so much kindling-wood; and whether they take fire at sea, or on a river, or at a wharf, the means of extinguishing the flames are almost nothing...The*

The Last Run of the Steamboat *Wawaset*

Wawaset seems to have been managed on the principle that, even in case of an accident, she could be brought to the shore, and the passengers saved. Accordingly, the boats were of no use, and the life-preservers were carefully stowed away where nobody could get at them to make use of them.[74]

Not all writers were ready to punish the people responsible for safety on steamboats. A letter to the *Evening Star*, signed by "C.W.," said that some people "are apparently prepared to certify that the burning of the *Wawaset* was a premeditated and cruel device." The letter concluded:

The Potomac Ferry Company did not burn their boat deliberately, and the sacrifice of life was an inevitable consequence, just as it has been on all similar occasions. What advantage is it to the people of Washington to attempt to fix special criminality upon the owners for this their first accident of the kind?

United States Secretary of the Treasury W.A. Richardson had directed a special panel of experts from the department's Steamboat Inspection Service to take action against the Potomac Ferry Company, the owner of the steamboat. Assigned to the panel were to be officials from U.S. Steamboat Inspection Service offices along the East Coast. Richardson assigned Commodore William Rose, inspector of hulls, stationed at Savannah, Georgia, and John E. Edgar, inspector of boilers at Norfolk, Virginia. Richardson apparently had been advised by John Menshaw,

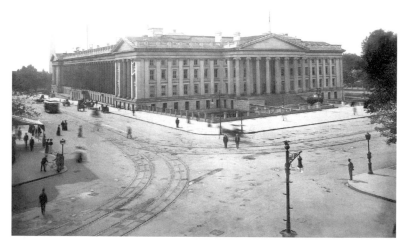

The Treasury Building in Washington, where the United States Steamboat Inspection Service conducted a hearing to determine cause and fault in the Wawaset disaster.

supervising inspector in Baltimore, that a member of his staff could not be appointed because of the potential for conflict of interest charges. Menshaw's staff had made the most recent inspection of the *Wawaset* in March, and the government would need to call Baltimore inspectors to testify. A third member, although not planned, turned out to be D.D. Smith, the supervising inspector general, whose office was in Washington and who was probably the man with the greatest profile in steamboat inspections in the country.[75]

On August 15, 1873, exactly one week after the steamboat *Wawaset* left Washington for a peaceful cruise on the Potomac River, a federal government hearing board convened in the sprawling U.S. Treasury Department Building to hear evidence that could help the commission in determining what went wrong and who might have been at fault.

The Treasury Department had a ready-made body for such an investigation. The U.S. Steamboat Inspection Service existed under a congressional act of 1838 "to provide better security of the lives of passengers on board of vessels propelled in whole or in part by steam." In a 1922 study, Lloyd M. Short wrote, "There was no logical basis for [the Treasury Department to head up the USSIS] except perhaps the fact that the customs officers were charged with the enforcement of the inspection laws."[76]

The new law set forth several requirements, among them: "inspection of hulls every twelve months and of boilers every six months; each vessel to have lifeboats, fire pumps and hose, signal lights, and other safety equipment...before passengers could be carried." Also, district inspectors were authorized to issue "a license certificate or certificate of inspection...which was required to be posted up and kept in some conspicuous part of the boat for the information of the public." This law "provided that any person employed on board a boat in which lives were lost through his misconduct, negligence or inattention to duty should be deemed guilty of manslaughter."

During the years after 1838, the law was refined several times. In 1843, steam vessels were newly required to provide additional steering apparatus for "emergency use such as in the event of a pilot being driven from the wheel by fire." In 1847, limitations were established on the number of passengers to be carried. Looking at these laws now, as the *Wawaset* owner and officers faced investigation, would add weight to the gravity of their conduct on August 8, 1873, and on their readiness for that trip.

The Last Run of the Steamboat *Wawaset*

The Steamboat Act of 1852 created "the foundation upon which a large part of the service" existed in 1873 and over a period of seventy years.[77] The 1852 act established nine districts, each headed by a supervising inspector, and firmly placed the secretary of the treasury in charge of the USSIS. That was changed in 1871 with the creation of "the Office of Supervising Inspector-General under direction of the Secretary of the Treasury." The new general's annual salary was to be $3,500 (2009 value: $63,000).

At the same time, the 1871 law broadened the types of vessels affected by inspection and engineer-pilot licensing regulations to include "ferry-boats, canal-boats, yachts, and other small craft of like character propelled by steam, tug-boats, towing-boats, and freight-boats." Lloyd Short's study points out that the 1871 regulations were aimed "toward the promotion of the security of the lives of all persons on board steam vessels, thereby giving the officers and crews of such vessels the lawful protection that formerly extended only to passengers."

The effect of all this was to bring together a rare hearing board. It is not likely that the Steamboat Inspection Service had been ordained often by a cabinet secretary to put on trial a steamboat's officers. The owner's and officers' actions, both on August 8 and before, were to be judged against standards set by law. Perhaps because of this lack of experience all around, the hearing was off to a poor start.

The hearing would take place in the Treasury Building office of General Smith, but Smith would arrive late. He was visiting western waters while serving as head of the congressional commission studying steam boiler explosions. When the proceedings began on August 13, the *Wawaset* owners and officers were to face federal government officials with wide steamboat experience, quite some difference from the unnamed local jurors pressed into service the week before on a Potomac River wharf. The officers' exoneration in Virginia may have seemed to them to be in doubt in Washington.[78]

Like the muffled beat of a funeral drum, the living continued to bury their dead. Phillip A. Sandy paid to have a card of thanks published in the *Fredericksburg Ledger*:

> *Having just returned from Washington City, where I have been to attend to the burial of my sister, Miss Pattie J. Sandy (who lost her life by drowning from the ill-fated steamer* Wawaset *while on her way to my home in Essex), I take this method of expressing my thanks to the very many kind friends who assisted me…The remains now rest in the soil of Virginia in a beautiful cemetery in Alexandria.*

Chapter 7

WHO WAS AT FAULT?

The supreme moment passed and with it all possibility of saving life.
—USSIS Report

The matter of licenses—who had them, who didn't and why—covered a large part of the *Wawaset* hearing in Washington. Both the passenger capacity license and officers' certification drew much attention from the hearing board on August 20. This series of testimonies began with a representative of the Potomac Ferry Company. Captain Samuel Gedney said that a company officer, S.S. Howison, "asked me to go to Georgetown with him and I saw a duplicate of a license calling for one hundred thirty cabin passengers and twenty steerage passengers." He claimed that this license was received at the Georgetown Customhouse, as required.

Gedney said that when the latest inspection, in March 1873, brought papers limiting passengers to only 30 in cabins and 20 on deck, he did not post them until he could review the matter with W.O. Saville, one of the Baltimore district inspectors. As a result, the *Wawaset* had made one or two trips without papers. Company officials were distressed with the huge reduction in passenger capacities, from 150 to only 50, Gedney said. Further, the *Wawaset* had only the previous year received a permit allowing up to 500 passengers on excursion trips.

Gedney showed the hearing board that permit. Dated June 3, 1872, it certified that Baltimore district inspectors had found the steamer complying with the laws and that "permission is hereby given to said

steamer to carry five hundred additional passengers, the route and distance…not to exceed eighty miles on the Potomac River." This permit was signed by Saville and James D. Lowry, USSIS local inspectors.

"This, however, was not an excursion?" a hearing officer asked Gedney.

"Well, when we get one hundred and thirty passengers, we consider it an excursion," Gedney responded.

When Gedney called Saville's attention to the discrepancy, Gedney quoted Saville as saying that he had "no idea how the mistake occurred. Mr. Lowry made the certificate on my desk in my room." Then, said Gedney, Saville assured him that "the inspection [certificate] would remain the same as last year. I am positive of that."

When a hearing officer noted that Saville's testimony did not agree with Gedney's on passenger limitations, Gedney pointed out, "Well, he said he inspected the boat in Baltimore, whereas the inspection was made in Washington." Again, Gedney quoted the inspector as telling him that the license "allowed us to carry one hundred and thirty cabin passengers."

Lowry was re-called to testify about the March inspection. He said he asked the *Wawaset*'s Captain Fowke, who had since died, "how many passengers do you want to carry? He said, forty, fifty, or sixty, so I placed it at sixty."

> *Q. Would you have given a certificate for carrying one hundred and fifty?*
> *A. No, sir.*
> *Q. How many would you have given a certificate for?*
> *A. One hundred and twenty, I think; I never said to Captain Gedney the certificate is all right, that there had been no change.*

Now two new figures had been introduced: 120 and 60. Complicating this even more was the death of Captain Fowke on March 27, only three days after the inspection. Gedney, with full authority over the company boats, was questioned.

> *Q. Who could it have been that you told the inspector to put in fifty?*
> *A. I don't know. Mr. Boswell, the pilot, was acting captain at the time.*

The board persisted with the number of passengers aboard. The assistant engineer, Samuel Nash, was asked the capacity as limited by federal inspectors.

> *A. One hundred and thirty cabin and twenty deck.*
> *Q. How do you know that?*

A. Because I read it. The certificate was hung in a walnut frame covered with glass. It is a very small amount of people for the boat to carry. I thought she was allowed to carry three hundred.

Q. Why?

A. Because she has so many life preservers on board.

The passenger capacity came up again on August 22, when Saville told of meeting Gedney at Alexandria. "Captain Gedney came to me and said, 'Has the *Wawaset* been reduced in her certificate?' I said, 'I believe not.' I am inspector of boilers, and did not think he had reference to passengers." The panel re-called Lowry, and he confirmed the accuracy of the copy of the certificate he had given the hearing, showing passenger capacity at only fifty and crew at fifteen. The board was to conclude: "This evidence was fully confirmed by the subsequent production of the original certificate itself from the files of the Georgetown custom house."

Louis F. Clements, the inspector of customs in Georgetown, testified that Gedney

called in and seemed to be troubled because the Wawaset *had been reduced. I told Gedney it must be a mistake, he had better see the inspectors and have it fixed. He asked me to send them down if I saw them. I said I would. About a week after, I was passing Captain Gedney and I said, "Did the inspectors fix that right?" He said, "yes." I don't know whether he understood my question or not.*

In fact, under questioning, Clements said that "the record stands in the Georgetown custom house" at 50, compared to 150 in the previous license.

If the law were enforced, the Potomac Ferry Company faced a heavy fine. The *Nautical Gazette* pointed out on August 16 that the penalty according to law was $10 per passenger, plus a refund of all passengers fares. That would run upwards of $2,000 (2009 value: $36,000).

Examination of a half-dozen witnesses made clear how confusing the passenger capacity question had become. Asa P. Snyder, a bookkeeper who worked on *Wawaset* accounts, told of reading a posted certificate on board. "It struck me forcibly," he said, "that the boat only being authorized to carry one hundred fifty passengers, often carried on excursions five hundred and upwards." He admitted he did not know if the certificate was dated 1873 or 1872.

The Last Run of the Steamboat *Wawaset*

George A. Shekel, president of the Potomac Ferry Company, told the hearing that normally "Captain Gedney is left with all matters pertaining to our boats," but Shekel said he did ask Saville on August 9, the day after the fire, if "she was only allowed to carry fifty." He was positive, he said, that Saville told him "that is a mistake; she wouldn't make much, a boat of her size, if she was only allowed to carry fifty."

Samuel W. Cox and Frank Wolf told of hearing Saville tell Shekel in the ferry office on August 9 that the limit was the higher number.

The board turned to the subject of licensing the steamer's officers. A member asked Captain Wood, "Were you not aware that a captain had to be licensed?"

> *A. Not until this investigation.*
> *Q. Are you not aware that there are steamboat regulations governing the service?*
> *A. Yes, sir.*
> *Q. Have you ever read them?*
> *A. A little; some portions of them.*
> *Q. Did you read that portion which required a captain to be licensed?*
> *A. No, sir.*

Clements was important in the process of staffing vessels; his job included issuing certificates under oath for new masters. John Wood had taken the oath from Clements only that spring. Clements's testimony about a master's license, then, was curious and significant.

> *Q. Were you aware that the captain of a steamboat ought to have a license?*
> *A. Well, to tell the truth, before this disaster I really did not. I thought his being endorsed as a master was sufficient. I have read the law since and found out my mistake.*

Questions about safety on the *Wawaset* occupied the hearing board for several days. The August 20 testimony introduced the subject of safety training for the *Wawaset*'s crew. Captain Gedney, on the stand as a Potomac Ferry Company official, answered questions as follows, according to the *Star*:

> *Q. Have you a practice about your boats of instructing the men in the* [boat's] *fire department?*

At Chatterton's Landing, a 2009 group orients an 1873 drawing of the sunken Wawaset. Photo by John C. Villforth.

A. No, sir.
Q. Not on this or any of your boats?
A. No, sir.

Captain Wood took the stand to continue the examination on safety training.

Q. Did you ever receive any orders to exercise your men upon the pumps, hose or fire extinguishers?
A. No, sir.
Q. Do you know from your own knowledge that all fire apparatus was in good order?
A. Yes, sir.
Q. How do you know?
A. Well, we used the hose to wash the boat, and one of the fire extinguishers was used on the fire.

After Smith's arrival, the panel resumed examining the crew on safety. The boat's firemen, Lorenzo Brown and John Forman, described their routine. The "fireman's room," they testified, had a lock but no keys; Brown did not smoke but Forman did, although not in the boiler room; the two berths in the

room were not used in the summer because of heat; and neither fireman had matches or had taken waste into the room on the morning of August 8.

When fire broke out, Brown testified, he was on the hurricane deck oiling machinery. Forman said he was off duty but went to the boiler room for his work clothing when he discovered fire.

> *Q. What did you see?*
> *A. I saw the smoke and fire opposite the back connection; back smokebox, we call it.*
> *Q. What was burning?*
> *A. Well, I couldn't say. I didn't stay long enough to see. I went on deck and reported it.*
> *Q. What did you think was burning?*
> *A. The side of the room opposite the bed and clothing. It was the board partition.*
> *Q. Have you any idea how that got on fire?*
> *A. I have not, unless it caught from the back connection.*
> *Q. Did you ever feel that partition to ascertain how warm it was?*
> *A. Well, it would sometimes get rather warm.*

Another of the issues raised in newspapers was the question of officers drinking on duty and even serving customers. At least one survivor claimed to have seen the engineer, Robert Nash, "behind the bar." This matter was not pursued further.

The government examination concluded on August 22, having heard forty-five witnesses during seven sessions. "Mr. Rose gave notice," the *Star* reported, "that the report of the commission would appear at an early day."

The hearing panel was to determine if the Potomac Ferry Company had exceeded the legal limit of passengers; if any of the *Wawaset* officers had failed to earn necessary licenses; and if the officers failed to meet standards of conduct in relation to drinking on duty, to maintaining a trained firefighting force and to servicing passengers' needs in time of emergency. This was a conscientious hearing board, and for those sitting with a foot or finger tapping nervously, it may have seemed that the final report was a long time in coming.

On August 29, true to the journalistic custom of one newspaper scooping the others, a Washington *Star* reporter predicted the findings "from an incidental conversation with those who have read the report of

the Treasury commission." The reporter, the story said—not the federal commission—arrived at the following conclusions concerning:

> *1st. It recommends the prosecution of the Potomac Ferry Company for employing in their service a captain and mate known to them to be unlicensed officers, and in flagrant violation of the existing rules governing the steamboat service of the United States. It also condemns them for allowing either the officers or crew of the Wawaset to engage as hucksters in the traffic of melons, fruits, vegetables, etc., the products of the Virginia and Maryland shores.*
>
> *2nd. It recommends the prosecution of Captain Wood and the mate, Mr. Gravatt, for accepting and serving in their respective positions in violation of the steamboat law, holding that ignorance in either case is no excuse. It is understood, too, to recommend the revocation of the license of the engineer for engaging in business as a trader, and for his failing to apply such means as were at his command to check the course of the fire. The officers are also condemned for not making an attempt to distribute the life preservers and lower the metallic lifeboat; also for failing to have a fire organization. The commission will report that in their opinion the origin of the fire is shrouded in mystery.*

The commission findings were dated August 25, a remarkably swift handling of the August 8 disaster. The long statement produced by the special commission was made public on September 1. The *Star* reporter had done well with his scoop based on "incidental conversation." He had the basic facts. But the official report was more detailed and considerably tougher in the language used to discuss its determinations of guilt.

The report was addressed to John Menshaw, supervising inspector of steam vessels in the Baltimore district, which included the Potomac River in its authority. In military style, it was signed by William Rose and John Edgar, panelists, and endorsed in turn by Menshaw and Smith, who wrote that they concurred with the findings. Smith forwarded the report to Treasury Secretary Richardson on September 1.

Excerpts from the USSIS report follow:

> *The board of investigation fully exonerate the local inspectors at Baltimore who made the previous annual inspection of the steamer from all blame in the premises, as the steamer was fully equipped in accordance with the requirements of law.*
>
> *It would appear from the testimony that the fire originated in the fireman's room, forward of the boiler; that it had been burning some time and was first*

discovered by one of the firemen when attempting to enter the room, the opening of the door of which admitted the air to the fire, and thereby caused the vessel to be enveloped in flames and smoke, and driving the engineer from his post…

There were no means of getting to the afterpart of the boat to assist the passengers, and that there was not one of the officers aft at the time the fire was raging.

Captain Wood, "thinking the fire was in the hold, [decided] he would go down quietly and put it out." When flames came to the hurricane deck, the captain "knew that she was gone and that it was impossible to save her," and the only chance was to

beach her as soon as possible. This is his own unprompted statement of what he saw and of what he thought. The saving of the boat seemed to be uppermost in his mind to the exclusion at that time of the preservation of the lives of the passengers, most of whom were helpless women and children…Instead, however, of assuming, and directing passengers to a position on the boat where they might provide themselves with life preservers, or of ordering the crew to prepare the lifeboats for use, he took some of the fire buckets with which to throw water on the tiller rope, leaving the passengers to crowd together so as to cut off all chance of escape. He told them to keep cool, and they would all be saved. Just at that time, the engine ceased to work, the boat stopped, the supreme moment passed, and with it all possibility of saving life through the appliances on board.

The testimony of

passengers of more intelligence, perhaps, and cooler observation seriously contradict the statements of the officers; these passengers assert that the officers permitted time to be lost; that they made no effort to save the lives of their passengers, especially the women and children; that the hose was not in its proper place; that the metallic lifeboat had no davits or falls attached to it and that the other boat was seized by a number of colored men, in the absence of any officer to prevent it, and thrown overboard in such a manner as to cause the loss of all its occupants.

It is alleged that the flames burst forth with such fury…the officers of the boat claim to have been unable to render assistance to the one hundred twenty-five odd passengers on board, hence the deplorable loss of life which ensued…We do not believe the statement of the officers that they did all

that could possibly have been done under the circumstances…which opinion is fully and clearly borne out by the evidence in the case.

The commission's findings concerning the officers' conduct follows:

We find from his own evidence that John R. Wood was acting in the capacity of master of the steamer Wawaset *without having a United States certificate of license as such and the evidence also clearly shows that he had not made himself acquainted with the provisions of the act of Congress and the rules and regulations relating to steam vessels, and the duties of the officers navigating them; that he had no organization or discipline whatever in the fire department on board his vessel…none of the officers were specially designated to take charge of the boats, life preservers or pumps, and no printed instructions were posted up concerning the matter of using the life preservers or other lifesaving appliances… Captain Wood further confesses that he never examined or tested the fire extinguishers, one of which was illegally removed from the steamer since her last inspection; never called the officers and crew to quarters for exercise in the fire department, as required by law to be done at least once in each month, and in many other respects failed to meet the requirements of the law in his capacity as master…*

Robert W. Gravatt, who was acting in the capacity of mate…was, like her captain, without a United States certificate or license, and equally as ignorant of the requirement of the laws, rules and regulations governing the Steamboat Inspection Service.

In his own testimony, the chief engineer [Robert Nash] *admitted the fact of his trading at different landings when the steamer was running on her regular trips, and particularly on the day of the disaster the evidence adduced also proved that he was at different times in attendance at the bar of the steamer during his watch and when the law positively demanded his presence at his post of duty in the engine room. It was also shown that the hose was not connected with the fire pumps, and that when the alarm of fire was given, Mr. Nash became perfectly paralyzed, and made little or no effort to extinguish the fire and none to save the lives of the passengers…The negligence and misconduct of the chief engineer of the steamer* Wawaset *prior to the burning of the steamer, as well as his unofficer-like conduct after the fire occurred, are, in our opinion, deserving of the condemnation and the highest penalty prescribed by law. We have therefore no alternative than to revoke the license of Robert Nash as an*

The Last Run of the Steamboat *Wawaset*

engineer on steam vessels navigating waters within the jurisdiction of the United States, and it is so ordered.

The Potomac Ferry Company, owner of the *Wawaset* and employer of the officers and crew, was examined for its role in the disaster. The company

was running the steamer Wawaset...*in open violation of the law, not only as regards the carriage of an excessive number of passengers, but also in employing unlicensed officers, and we earnestly recommend that steps be promptly taken by the proper officers of the government to impose upon said company the extreme penalties of the law for such violations; as also upon John R. Wood, the master, and Robert W. Gravatt, mate of the* Wawaset, *for plying their respective* [duties] *without United States licenses, in defiance of the law.*

What all those hours of testimony and examination of records came down to was this:

1. The Potomac Ferry Company should be prosecuted for overloading the *Wawaset* and hiring unlicensed officers.
2. The captain and mate, Wood and Gravatt, also should be prosecuted for not being licensed.
3. The engineer, Robert Nash, should have his license removed.
4. The cause of the *Wawaset* fire would forever remain a mystery.

The question now became: would the government act as the board recommended? It did not take long before the doubters appeared.

Chapter 8

The Years After

In the Treasury Building in Washington, the military system of referring matters up and down the chain of command was to continue. The secretary of the treasury very likely read the special *Wawaset* commission report and handed it over to E.C. Banfield, the department's solicitor. That lawyer in turn referred the matter for court action to the United States attorney for the District of Columbia, a veteran lawyer and judge named George Purnell Fisher. In 1873 Washington, the U.S. attorney was also the "district attorney," appointed by President U.S. Grant in 1870. In this case, the prosecution buck stopped with George Fisher.

Lawyers not involved in the disaster on the Potomac in 1873, no less than attorneys today, were willing to discuss the federal government's investigation and the findings against the owner and officers of the steamboat *Wawaset*. On September 3, the *New York Times* reported a prediction that

> *enforcement of the penalties provided by the Steamboat law are likely to bring on an investigation before a jury, which it is claimed will produce a different result from that before the steamboat inspectors...* [I]*t is openly asserted by prominent lawyers that the report in the case is not sustained by the evidence.*

At least one issue was obvious—the passenger capacity. The claim now by anonymous attorneys was "that the preponderance of evidence shows that the steamer was entitled to carry one hundred fifty passengers and

The Last Run of the Steamboat *Wawaset*

the government cannot punish the vessel owner for the blunder of its own officers."

D.D. Smith, the inspector general of the United States Steamboat Inspection Service, was sharply criticized by some anonymous observers for involving himself in the hearings. It was his province "to pass judicial judgment upon the report of the board," and his doing so was unfair and prejudicial to the defendants. General Smith, the accusation charged, "incited the board to a partisan decision by appearing before it hastily at the close of its sessions, and commenting on the case in a manner equivalent to a dictation of its decisions." As a result, the unnamed *Times* source predicted, "the case is likely to be thoroughly reopened in court."

Smith had indeed given his strong opinions before the commission on August 20. On one issue alone—the qualifications of John Wood to be a steamboat captain—Smith had said:

> *I do not propose to sum up this testimony, but this captain, who has just appeared upon the stand, it is very evident from his statement and from the statement of the superintendent, that there had been great want of discipline, order and proper authority on the* Wawaset. *Whether system would have saved life or saved the boat I am not prepared to say.*

After being criticized for speaking out, Smith was undaunted. He seemed to challenge any court assigned to hear appeals. Using equally strong terminology, he countered, "The *Wawaset* is the first instance of flagrant disobedience to the law. This will be a test case to see what is in the law and how far violations can be punished." Smith was to admit that punishment of all future violations would be unlikely. He said, "There are not sufficient means to frequently inspect," as the commission had recommended. But he added his hope that "the *Wawaset* disaster, unfortunate as it was, will insure increased safety to passengers traveling on steam vessels."

While cloakroom lawyers argued the case, the Potomac Ferry Company reorganized and kept busy on the river. The steamer *Kent*, put into tentative service almost immediately, had been replaced permanently in October by the *Palisade*.[79] The company announcement said the *Palisade* had been taken from the Norfolk and Richmond Line and the *Kent* "is undergoing repairs in Baltimore." Meanwhile, the company collected on its insurance on the *Wawaset*. While the steamer was appraised at $40,000, the policy covered only $28,000 (2009 value: $540,000), surely well below the vessel's actual worth.

The year 1873 was a bad year for fire underwriters. The Thanksgiving week cartoon in the Chronicle showed a tiny turkey marked "dividend."

The observers who guessed that the *Wawaset* case would not go to court were right. District Attorney Fisher was unheard on the matter for more than two months. The fifty-six-year-old was no newcomer to Washington's inside politics. After college and admission to the bar in his native Delaware, Fisher had served in many state positions and advanced to Washington with the new U.S. Secretary of State John Clayton, for whom he had served as law clerk. More than six feet tall, Fisher had a Lincoln-like demeanor. He was to impress several U.S. presidents during his long years away from Delaware. He had served briefly as private secretary to Millard Fillmore after the unexpected death of Zachary Taylor and was named by Lincoln in 1863 as one of four justices to the new Supreme Court of the District of Columbia. For the rest of his life, Fisher was addressed as "Judge"— even after 1870 when Grant appointed him the U.S. attorney for the district. By the time he was handed the *Wawaset* case, he had been in the district office more than three years, had become portly, wore a moustache and had let his hair grow long. He was always known to wear bowties.

When finally, in November 1873, Fisher announced progress in reviewing the several violations claimed by the treasury's special commission, his decision could be seen as either finding ways around the laws to avoid prosecution or doing his best with anemic and vague steamboat laws. Fisher did agree with the federal commission that Captain John Wood and Robert Gravatt, the mate, had violated the congressional act of February 28, 1871, by serving without license. Fisher, therefore,

would seek court orders to fine each of them $100 (2009 value: $1,800), as provided by law. That is, Fisher said, he would take only that action unless instructed otherwise—presumably by either President Grant, who had appointed him, or by Secretary Richardson, who had turned over the case to him. Under an 1871 law, Wood and some of the other officers could have been charged with manslaughter, with a penalty of up to ten years in prison. Fisher did not feel that he had sufficient evidence to prosecute. The law allowed no lesser charge involving the deaths of so many passengers.

Much as the news reporters and anonymous attorneys had predicted, Fisher found another area in which he could not agree with the commission's decision: the number of passengers the *Wawaset* was permitted to carry. Elizabeth Lawrence, writing in the *Washington Post* in 1969, told the story this way:

> *District Attorney Fisher…felt there was not sufficient evidence of misconduct or inattention to duty to convict any officer or employee of the crime of manslaughter at this time; nor of fraud, connivance or misconduct against any owner or inspector, in consequence of which the life of any person was destroyed…From the fact that the certificate* [of inspection] *ending March 8, 1873, had read one hundred fifty passengers, he was convinced a mistake had been made when the new certificate was issued and it "should have read one hundred fifty, thirty more than were on board."*

As he had with the Wood and Gravatt fines, the district attorney seemed to throw a procedural challenge, at least to the treasury secretary or to his solicitor, by adding: "He would prosecute only with specific instructions."

Those instructions never seem to have been given. The *Wawaset* case was concluded. How the case might have ended with another district attorney was left for future speculation when Fisher was asked to resign less than two years later. The second headline on a *New York Times* July 17, 1875 story explained why: "No charges affecting his integrity—His shiftlessness the cause of his removal—Too much partisan politics in the judicial proceedings." The story added:

> *It has been apparent for some time that new life must in some way be infused into the prosecutions here, and two or three causes of complaint were recently pointed out in these dispatches. One trouble has probably been the introduction into the judicial proceedings of too much partisan politics, both national and local.*

A bit of irony developed in 1889 when Fisher accepted a four-year appointment by President Benjamin Harrison as the first auditor of the United States Treasury. Although Fisher had been professionally unable to accommodate the secretary of the treasury in 1873, Fisher was fully able to do so sixteen years later, serving out the full four-year term at age seventy-five.

As inspector general, Smith no doubt saw to it that new and efficient inspections were begun within two months. The *Washington Chronicle* reported:

> *Since the* Wawaset *disaster a special inspection has been made of all the steamboats plying in the Potomac waters, and the inspectors pronounced the* Columbia, *plying between here and Baltimore, as not only complying with all the requirements of the law, but even complimented the owners of the boat on the extra precautions for the safety of passengers, while three others were passed even, and one, which is said to be the finest steamer on the river, was fined $100.*[80]

The U.S. Steamboat Inspection Service continued to be active into the twentieth century, but its reputation never improved. A commission appointed to investigate the *General Slocum* disaster in 1904 presented "a stinging indictment [of the USSIS] and its shortcomings," Edward T. O'Donnell wrote in his history of the steamboat tragedy in New York.

In the immediate weeks after the focus on the legal hearing had faded, the business of clearing the Potomac's shores went on. Burial sites on and near the beaches in King George County apparently never became permanent. While the legend of a "Wawaset Cemetery" in the community of King George has persisted even to today, the reburial of victims in recognized cemeteries continued over time. The same is true about memorials erected along the riverbanks. Finding one now is considered by residents to be a hopeless task.[81]

Most of the passengers, and therefore the victims, had made Washington their home, and so their remains were taken there by steamboats whose service was volunteered by owners and crews. The Congressional Cemetery became the final resting place of ten drowning victims, including all six of the Reed family, Sarah F. Muse and her son Willie, George W. Cooke and Henry H. Hazard. Sarah J. Reed, Joe's wife, had been buried initially in King George County, but Reed had the remains exhumed and brought to Washington for burial. Funeral ceremonies for her were held first on

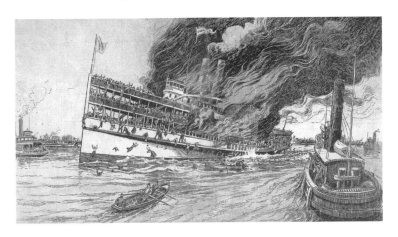

The General Slocum, with 1,300 passengers, burns during a 1904 New York excursion, killing 1,021. Maritime Museum, Newport News, Virginia.

Saturday, October 11, at King George County, and the body was reburied on October 15 at Congressional Cemetery.[82] Joe Reed himself was placed in the Reed family site upon his death in 1928.[83] That area, about fifty feet inside the main gate at 1801 E Street Southeast, is recognizable by its monument with five interconnected stones.

The *Evening Star* of October 27, 1873, reported the death of Miss Emma Lynch, the sixteen-year-old daughter of the late Daniel Lynch. She "died of consumption during the past week, and was buried on Saturday [October 25] from her lodgings on Sixth Street East. Her death was hastened by the sad fate of her father." In all, the Grant-Lynch family lost five members in less than three months.

Founded in 1807 by Christ Church Episcopal as the Washington Parish Burial Ground,[84] this large, open area on the north bank of the Anacostia River was by 1840 called "Congressional" or "Burial Ground," according to an *Evening Star* writer. The ground has the graves of many notable citizens. Among them over the years have been two vice presidents of the United States, Elbridge Gerry, a signer of the Declaration of Independence, and George Clinton, a former New York governor;[85] Secretary of State Abel Upshur, killed in an 1844 ship explosion; Tobias Lear, George Washington's secretary; Push-ma-ta-ha, a Chocktaw chief; a U.S. attorney general (1817–1820), William Wirt; U.S. Supreme Court Associate Justice Phillip P. Barbour; thirteen U.S. senators; sixty representatives; three commodores; ten admirals; several generals; and twenty-one women killed in Washington's 1864 arsenal explosion.

Several historic figures were placed at Congressional Cemetery while arrangements for permanent entombment were being made. These included Presidents John Quincy Adams, Zachary Taylor and William Henry Harrison; John C. Calhoun; Dolley Madison; and Louisa Adams. The cemetery has also come to be recognized for having eighty-five Latrobe cenotaphs, named for designer Benjamin Latrobe. These stone monuments honor distinguished Americans buried elsewhere. Along the paths and roadways are the graves of other notables. Former Mayor Sayles J. Bowen is there, along with nine other nineteenth-century mayors. Among the most visited grave sites in the twenty-first century is that of the former head of the Federal Bureau of Investigation, J. Edgar Hoover. Perhaps the most popular is the final resting place of John Philip Sousa. Every year, his grave is visited by the United States Marine Corps Band, which he once conducted, and numerous high school bands from around the country.

There are, of course, graves for many people who had less spectacular careers. One of them was Becky Smith. Released from the "Washington Asylum" in 1846, she lived near the cemetery for fifty years and saved enough money to buy a Congressional Cemetery lot. A Library of Congress "American Memory Home" report[86] adds:

Indigents, African Americans and "infidels" were given grave sites outside the cemetery's walls in Potter's Field, so-called. The landscape of Congressional Cemetery still reflects the form of these social structures.

This report explains that the original burial ground form was influenced by the rural cemetery movement and, with a late nineteenth-century addition of land, "bears the mark of the lawn cemetery movement."

Some Potomac activities were not changed by the disaster. Less than two weeks after the *Wawaset* disaster, on August 20, 1873, a tournament was conducted at Glymont for the benefit of St. Charles Church, also called "the Neck Church." The *Washington Star*'s "Rambler" column on May 9, 1920, recalled that "Miss Melinda Rhodes of East Washington was crowned Queen of Love and Beauty."

The 1873 annual report of the U.S. Steamboat Inspection Service disclosed that John Wood, the captain running without a license,

has since made application for a license to the local board at Baltimore and been refused on account of his proven incompetency. The license of the chief

engineer of the steamer [Robert Nash] *was also revoked on account of his unofficer-like conduct at the time of the disaster.*

Over the following years, principals in the *Wawaset* case showed up here and there in the news. Joe Reed was in the police news a few times, not as a cop himself but as a suspect or defendant. During his long life—he would live to be in his nineties—Joe ran a cigar store and had other entrepreneurial adventures. He was brought in a few times for fighting or otherwise displaying a temper but always escaped major punishment. He had a creative side, too. In the records at Congressional Cemetery are poems attributed to Joe at the deaths of Sallie in the *Wawaset* disaster and then a fourth child, Owen, who died in infancy. Joe Reed's sad life apparently was played out in the Seventh Street neighborhood where he lived with his three brothers after a childhood in Westmoreland County, Virginia.

The site of the Reed family home is now occupied by the Jefferson School, and standing in place of Joe's cigar shop is the Federal Bureau of Investigation.

There seems to be no funeral record of Alethea Garnett Gray, the young mother who died within sight of her waiting husband at Chatterton's Landing. Absent any solid information, King George County history leans on the side of believing that her body rests there still. Elizabeth Lee, curator of the King George County Museum, reports:

Although there are no marked graves there, I strongly believe that she is buried in the old Spy Hill slave cemetery. It was used by the former slaves many years, up into the 20th century. I visited the Spy Hill slave cemetery in the 1980s. I stood in the midst of periwinkle and could have cried. There was obviously the largest cemetery I'd ever seen without any markers. That was the saddest thing.

Most of Alethea Gray's family is buried at Spy Hill. Mrs. Lee said that King George County records of the family, on file with the Virginia Bureau of Vital Statistics, show that two daughters lived only into their teens: Lou Ida, born in 1866, died October 11, 1880, and Laura, born in 1870, died November 15, 1885. Buried at Spy Hill with them is their father, Cornelius Gray, and the girls' brother, George Allen Gray. Born in 1872, Allen was an infant at the time of Lethy's death. He lived sixty-two years, until September 24, 1934. Cornelius was seventy-one years old when he died on July 4, 1913.

Said Mrs. Lee, "I'm so glad Ruth Taliaferro found the information that she did and that we were able to piece together the cemetery records

King George County Museum curator Elizabeth Lee examines shards found on a beach near the Wawaset's sinking. Some shoreline residents have found dinnerware pieces they believe might have come from the sunken steamboat. Photo by John C. Villforth.

as best we could." Mrs. Taliaferro and her husband are present-day owners of Spy Hill. The information is open to the public at the King George County Museum and Research Center.[87] In 1880, Cornelius, Lucy, Laura and George Allen Gray were living in a household in King George. Cornelius later was to marry Malinda Turner, according to county records, and probably continued to work at Spy Hill all his life.

Discrimination against African Americans continued for decades through "separate but equal facilities" rulings. Slowly, progress was made. A Currier & Ives 1872 lithograph shows the nation's "first colored senator and [six] representatives."[88]

In 1911, the District of Columbia Association of Oldest Inhabitants, a still active history society, discussed the idea of erecting a monument to the *Wawaset* dead at Chatterton's Landing, but it never happened. A *Washington Post* story on August 22, 1911, said: "Many graves of Washingtonians there have long since been obliterated by the elements." The story credited Robert Adams and his rowboat with saving "fifteen to twenty" lives at Chatterton's Landing and creating a burial ground called "God's Acre." Joe Reed, then in his seventies, was quoted as favoring the proposal.

For a time, the *Wawaset* sinking served also as a marker in the lives of those living in the area. Betty Carter Smoot, whose husband's name is on the public library in King George, told of a young relative visiting the Carter family in their Washington home on August 7, 1873. The girl had planned to board the steamboat to return home on August 8, Mrs. Smoot wrote,

but a young man, a friend of the family, persuaded her to remain over and visit a show which was in Washington at the time. It was a close call; even had our young friend escaped with her life, the recollection of that day of horror must need have haunted her for many a year.[89]

In 1948, a seventy-nine-year-old woman brought the story back to life. Leonora Fowler Rowles was ten when her Sunday school class at Washington's Mount Vernon Place Methodist Church arranged to take the *Wawaset* to its picnic at Marshall Hall. She recalled preparing on August 7 for the trip. The next morning, Leonora's mother forbade her from attending. Mrs. Fowler had had a dream about the boat, the *Washington Post* reported on May 17, 1942. "The strangeness and narrowness of [Leonora's] escape from the tragedy had bothered her the remaining sixty-nine years." She asked the newspaper to help her locate any survivors, although she believed she was the last member of the class. She died in 1948.

Residents near Chatterton's Landing have found shards of dinnerware they believe might have come from the abandoned vessel. A Maryland

Dinnerware, some bearing marks of British manufacturers, still shows up on Potomac beaches. Beachcombing residents believe these pieces came from the Wawaset. Photo by John C. Villforth.

A Colorado gun manufacturer goes back in history with a 2009 rifle showing "The Wawaset" on the walnut gun stock. In fact, the boat was not a stern-wheeler. Photo submitted by Wellington, Ltd.

Wellington gun manufacturer encourages sales with this weapon decorated in celebration of King George County, Virginia. Photo submitted by Wellington, Ltd.

archaeologist and others have expressed an interest in diving if the wreck can be located.

William Emerson, the passenger who found and used life preservers for himself and his daughter, carried his preserver with him on the boat returning him to Alexandria. He had told several friends "who congratulated him upon his lucky escape that he would keep it as long as he lived."[90]

The *Wawaset* lives on in other ways. A Loveland, Colorado gun manufacturer, Wellington, Ltd., has created a "King George County, VA, Special Edition" rifle with a steamboat image and the word "*Wawaset*" applied to the walnut stock. Wellington's website states that its "limited edition rifle is…a tribute to the history and people of King George County." One side has images recognizing the "attack on secession batteries at Mathias Point, June 1861"; King George I, for whom the county was named; and "the famous river steamer '*Wawaset*.'"

The Last Run of the Steamboat *Wawaset*

Books about the steamboat era can be found on most public library shelves, and new ones come out with some regularity. Besides the book you are reading now, another published in 2009 is the Maryland Historical Society's *Chesapeake Ferries: A Waterborne Tradition 1636–2000*, written by the late Chestertown, Maryland author Clara Ann Simmons.

The King George area today is much as it was when the steamboat went down: quiet, rural, self-contained. Walking on the private beaches with children and pet dogs is common. A few commercial places serve food and drinks. Because the Potomac is legally in Maryland, casinos attract gamblers.

In the 2,579-acre state park known as Caledon Natural Area, rangers maintain as public exhibits Boyd's Hole and Stuart's Wharf, which had roles in the *Wawaset* story. An old tobacco warehouse represents the heavy agricultural use of the land. Among Caledon's main effort is the preservation of the region's bald eagles, as many as sixty. The attention-getter, however, remains the Potomac River. It may be muddy in color, given the scores of motorized boats operated from its shores, but the river serves more than ever both utilitarian and recreational purposes. Excursion boats still run from Washington, but there hasn't been a steamboat operating on a schedule in American waters since before World War II.

If any good can be said to have come from the *Wawaset* disaster, it might be in the official and professional efforts of the government and maritime principals in generally following the special

After World War I, more than one hundred surplus wooden vessels were gathered at Mallows Bay, Maryland, on the Potomac River to be destroyed by burning. One apparently broke loose in the 1930s and was beached just hundreds of yards from where the *Wawaset* went down. Photo by John C. Villforth.

Stanley Palivoda restored this paddleboat at his Machodoc Creek landing. Twin diesel engines drive the stern-wheeler Vivian Hannah throughout the King George area, often loaded with guests from service and charitable groups. Photo by Ralph Peregory.

commission's recommendations for future action. That board concluded its study with the following remarks:

> *We recommend that inspectors require all bulkheads, boilers, hatches, or other woodwork near or around the boilers of all steam vessels to be covered with metal, leaving sufficient space for the air to circulate between such metal coverings and the woodwork as a preventative against future disasters to steamers by fire.*
>
> *As a further safeguard against the recurrence of similar disasters to steam vessels, we respectfully recommend [that] inspectors in the various districts [make] it a special duty to visit steamers from time to time and without previous notification sound alarm of fire and call all hands to quarters and in this way ascertain and correct defects in the organization and equipment of such steamers.*

By 1873, railroads had begun overtaking riverboats. Potomac service above Washington was soon to be abandoned. "In the inevitable march of technology," as one historian noted before nuclear power came into wide use, "the reciprocating engine has been replaced by the steam turbine and diesel in marine use."[91]

The Potomac River has adjusted to whatever modern life brings. It always has; it always will.

Appendix A

PASSENGERS ON THE *WAWASET*

A s best as can be determined in 2009, about 160 people were on the *Wawaset* on August 8, 1873—144 or 145 passengers and 16 crew members. Taking into account that not all passengers were aboard at the same time—as the steamboat stopped at Maryland and Virginia ports, she discharged and admitted passengers, thus changing the number at each landing—a best estimate might be that approximately 135 was the maximum number of passengers on the *Wawaset* at one time. Add to that the crew, which consisted of 15 men and 1 woman, and the total number of people on the boat at one time comes to about 150.

To arrive at the number 145, I began with the passenger list below. The official list was lost in the fire. My list includes 125 individuals. Those who are not named were otherwise identified as being with a relative or someone who was named. Newspaper reports during the days after the boat's sinking seem to settle on an additional 20 persons as either "unidentified" or "unrecognizable," and 8 of them may have duplicated others listed at the same time as "lost" or "died." The 8 included one African American woman found in grappling operations around the wreck in the Potomac and 3 white women and 4 African American children whose bodies were returned to Washington by the steamboat *National*. Also unidentified when their badly decomposed bodies were buried onshore were 9 African American women and 3 children not identified by color or name. These numbers—20, 8 and 12—total 40. I've assumed that the duplication at most would be double; that is, there were 20 women, men and children who died but for whom names

Warren Veazey (seated) and his father, Ed Veazey, live and work along the shoreline near Chatterton's Landing and, like many area residents, maintain a deep interest in Potomac River history. Photo by John C. Villforth.

were not immediately made public. Those 20 plus the 125 listed below total 145. The crew brings the grand total to the rounded-off number of 160.

As to the number who died, the newspapers seemed to settle on a figure around seventy-five. This list has forty-eight; adding twenty or more "unidentified or unrecognized" brings the total near or into the seventies.

This list presents passenger names as spelled in 1873 newspaper reports. Reasonable variations of spellings are included in parentheses. Where possible, I have opted for the simpler spellings. More difficult was determining which reports to accept—did the person die or was s/he saved? An example is Robert Olive. The *Washington Morning Chronicle* alone among several periodicals listed him "saved"; I opted to go with the majority.

The names of those who died are in *italics* and those with injuries appear in **bold** type. The actual number of those who were hurt would have been much higher, but I have listed only those reported as injured in newspaper accounts. "W/C" represents the designations given for "white" and "colored" people. In at least one case, one person was listed in both categories. That information is included here as an aid to those researching genealogy records.

NAME	HOMETOWN	W/C	ADDITIONAL INFORMATION
Robert Adams			"Rescued Kate McPherson"
M.C. Ashton (McAshton, MacAshton)		C/W	
Maria Ball		C	
Lavinia Barnard (Bernard)		C	"Child"
Benjamin Bartlett		W	
Nancy Baylis (Baylor)		C	
Rozier D. Beckley			
Hiram Blackwell	**Westmoreland County, VA**	C	**"Badly burned"**
Mary Blackwell		C	**"Slightly burned"**
Mary Blackwell	*Westmoreland County, VA*	C	*"Child"*
S. Blackwell		C	
Simon Bland		C	*"Buried by Mr. C.G. McClelland"*
No ID Braxton		W	"Boy; left *Wawaset* at Smith's Point"
Rozier D. Breckley	Alexandria, VA	C	Male
James Brooks		C	
William Brooks		C	**"Burned slightly"**

NAME	HOMETOWN	W/C	ADDITIONAL INFORMATION
John Brown	*Washington*	*C*	*"Shoemaker"*
Mary Campbell		C	
J. Christopher		C	Male
Julia Christopher		C	
R.A. Coates		W	Male
George W. Cooke (Cook)	*Washington*	*W*	*"Grocer 7ᵗʰ St. Washington"*
Leslie Cooke	Washington		Boy, 13; son of George
No ID Cooke	Washington		Younger child of George
Thomas Croxton		C	
George E. Dummer	Washington	W	*Morning Chronicle* typesetter
Matilda Dunlap		C	
Orrin Eddy	Washington	W	Male; "resides at 7ᵗʰ and H streets"
William E.(T.) Emerson	Alexandria, VA	W	
No ID Emerson		W	Daughter of William Emerson
E. Emsloiler (G. Emerlvie and S. Emsiviler)		W	Male
Mahala Fleet	Washington	C	"Residing somewhere near City Hall"
No ID Fleet	*Washington*	*C*	*Child of Mrs. Mahala Fleet*

Passengers on the *Wawaset*

NAME	HOMETOWN	W/C	ADDITIONAL INFORMATION
Robert Gaston		C	
Moses Gordon		C	
Mrs. Grant	*Washington*		*See under Daniel Lynch*
Mollie Grant	*Washington*		*See under Daniel Lynch*
Alethea Garnett Gray	*King George County, VA*	C	
Hester Griffin	*Alexandria, VA*	W	*"Daughter of Captain Ragan"*
No ID Griffin	*Alexandria, VA*	W	*"Child 1 of Mrs. Hester Griffin"*
No ID Griffin	*Alexandria, VA*	W	*"Child 2 of Mrs. Hester Griffin"*
No ID Griffin	*Alexandria, VA*	W	*"Child 3 of E.G. Griffin"*
Matilda Haney		C	*"Domestic of Z. Richards"*
Edwin Hawkins		C	
Henry H. Hazard Sr.			*"Old man"*
William Herring		C	
Charles Herron	King George County		
Child Herron	King George County		Daughter of Charles Herron
Cornelia (Cordelia) Hobbs (Hobb)	*Washington*	W	*15; "Under protection of Mr. McGuiggan"*
John Hughes		C	
Miss Irwin	*Alexandria*		

105

NAME	HOMETOWN	W/C	ADDITIONAL INFORMATION
Lindsay Jackson		C	
Sarah Jackson		C	
William Johnson		C	
Julia A. Kelly	*Currioman, VA*	*W*	*Aunt of Joseph W. Reed*
S.B. Kickwell		C	Male
Daniel Lynch	*Washington*		*"A tailor in this city"*
Annie Grant Lynch			*"A widow," wed August 6, 1873, to Lynch*
Mollie Grant			*Child of Mrs. Lynch*
No ID Grant child 2			*Child of Mrs. Lynch*
Mrs. Peyton Manning		*C*	
Virginia Marbury	*Petersburg, VA*	*W*	*"Clerk in Treasury Department"*
J. Wilkie Massay			
Thomas H. Massey (Massie)		W	
Eliza Matthews		C	
A.G. McGuiggan	Washington	W	*Morning Chronicle* typesetter
Kate McPherson	**Glymont, MD**	**W**	**"Slight burns on shoulder"**
Andrew Melville		W	Age 53
Richard Murray		*C*	

Passengers on the *Wawaset*

NAME	HOMETOWN	W/C	ADDITIONAL INFORMATION
Sarah F. Muse	*Washington*		*Wife of William Muse*
Willie Muse	*Washington*		*Son of William and Sarah F. Muse*
Ephraim Nash	Northumberland, VA	W	Farmer
James Newman	Washington	C	
Mary Norman		C	
J.B. North		W	Male
Robert Olive		*W*	*Boarded at Liverpool Point, MD*
Thomas Owens (Owen)		W	
George Parker		C	
Susan A. Parker		**C**	**"Badly burned"**
Sarah Payne		C	
Ann G. Peyton		*C*	
Belle Price		W	
No ID Price		W	"Child with Miss Belle Price"
Susan Randall	*Washington*	*C*	*"Buried Potter's Field"*
Elizabeth A. Reed	*Washington*	*W*	*"Bettie," age 17; Joseph W. Reed's niece*
John W. Reed	**Washington**	**W**	**"Badly burned on face and head"**
Joseph B. Reed	*Washington*	*W*	*Son of Joseph W. Reed, age 4*

Appendix A

Name	Hometown	W/C	Additional Information
Joseph W. Reed	Washington	W	Police Officer Reed left at Alexandria
Marian (Manie) Reed	*Washington*	*W*	*Daughter of Joseph W. Reed, age 2*
Sarah F. (Sallie) Reed	*Washington*	*W*	*Wife of Joseph W. Reed*
Sarah L. Reed	*Washington*	*W*	*Daughter of Joseph W. Reed, age 7*
Rhode Rice	*Washington*		*"Evidently a young man"*
No ID man			*Found with Rhode Rice; "with gaiters"*
Laura A. Rich	*Washington*	*C*	*"Wife of Tiffany Rich"*
Tiffany Rich		C	Male
No ID Rich	*Washington*	*C*	*Child of Tiffany and Laura Rich*
Bertie Sanders(Bettie)	*Currioman, VA*		*Unmarried woman*
No ID child	*Currioman, VA*	*C*	*Female child with Miss Bertie Sanders*
William Sanders (Saunders)		C	
Pattie J. Sandy	*Westmoreland County, VA*	*W*	*Unmarried woman*
John Scott		C	
Lemuel Scott		C	
Charles Shanklin (Shankland)	Washington	C	

Passengers on the *Wawaset*

Name	Hometown	W/C	Additional Information
Julia Shanklin	*Washington*	C	*"Child of Mrs. Shanklin of Capitol Hill"*
Julia Shanklin (Shankland)	Washington	C	"Mrs. Julia Shanklin lost a child"
Hiram Smith		C	
Andrew Stand (Andrew Stoud, A. Strowd)		C	
Henry Street		C	
Charles Strickland		C	
J. Tait (Tate)		C	Male
Fannie Taylor		C	*"About age 30"*
No ID child			*"Child of widow Taylor"*
H. Taylor		C	Male
Mrs. Laura Taylor	Alexandria	W	
Mrs. Overton Taylor	Alexandria	W	"Widow lady with small valise"
No ID Taylor			"Sister's boy" with Mrs. Overton Taylor
Charles Thompson			
Cora Walker	*Washington*		*Also listed as "Mrs. Matilda Walker"*
M. Walker		C	Male

APPENDIX A

NAME	HOMETOWN	W/C	ADDITIONAL INFORMATION
Daniel Ward		C	
Juliana Willis (Wills)	*Washington*		*"Niece of Mr. and Mrs. Cobaugh"*
Daffrey Winters		C	Female
John H. Wise	Washington	W	
Isaac Wood	*King George*	*C*	*50 years old; in county death records*
James H. Wood		C	"Boy"
Lewis (Levi) Woody (Woodey)		C	
No ID child	*Washington*		*"Parents reside on Madison Street"*

MEMBERS OF THE *WAWASET* CREW—16

NAME	POSITION	W/C	ADDITIONAL INFORMATION
John W. L. Boswell	**Pilot**		**"Burns about arms and legs"**
Lorenzo Brown	Fireman	C	
Edward Day	Deckhand		
John Forman	Fireman		

Passengers on the *Wawaset*

NAME	POSITION	W/C	ADDITIONAL INFORMATION
Robert W. Gravatt	Mate		
Adeline Jenkins	*Chambermaid*		*Body taken to hometown, Occoquan*
Charles Jones	Deckhand		
Henry Lewis	Deckhand		
Peter McKenney	Bartender		
Samuel A. Nash	Assistant engineer		
Robert Nash	**Chief engineer**		**"More or less burned and injured"**
George Tibbs	*Deckhand*	*C*	
Charles Tolson	Steward		
J. Watson Wheeler	**Clerk**		**"More or less burned and injured"**
William Washington	Cook-steward		
John R. Wood	**Captain**		**"Burned around the neck and ears**

Appendix B

The Steamboat Inspection
Service Report

There are two reports of the United States Steamboat Inspection Service hearing to determine the cause of the *Wawaset* fire and resulting deaths. One was issued within days of completing the investigation and is reported in chapter 7 in this book.

The other is printed in volume 14 of the *Proceedings of the Board of Supervising Inspectors of Steam Vessels, 1852–1899*, a section from the 1873 *Annual Report of the Third Supervising District*, pages 152–53. It was typewritten on four three- by five-inch index cards. The cards carry the information "Form 924A, Department of Commerce," which dates the record as having been typewritten after 1903 when commerce succeeded treasury as home of the service. The steamboat name is misspelled "*Wawassett.*" This four-card report is a summary of the official report issued August 25, 1873, which ran to five typewritten pages, single spaced. The 1903 report has the benefit of recording license applications and official action after the commission hearing thirty years earlier. The following is the summary report from the index cards:

> The steamer Wawaset, *belonging to the Potomac Ferry Company, caught fire on the 8th of August, on the Potomac River, about forty miles below Washington, and was entirely destroyed. As nearly as could be ascertained, about 82 lives were lost by this sad calamity. The steamer had but a short time prior to the*

disaster been thoroughly overhauled at Baltimore, and was at the time of the disaster fully equipped with all the life-saving appliances required by law.

The case was thoroughly investigated at Washington by William Rose, inspector of hulls at Savannah, and John E. Edgar, inspector of boilers at Norfolk. The steamer's certificate of inspection allowed her to carry but fifty passengers, while it was proven in the investigation that at the time of the burning there were more than one hundred passengers on board.

When the fire was first discovered the captain gave orders to run the boat ashore; the breeze being ahead, the flames were driven aft among the passengers there, creating a great panic among them, some of whom took possession of the life-boats, and not knowing how to manage them, they were broken and swamped, and nearly all those in the boats were drowned. The captain and his principal officers, including the engineer, were on the forward part of the vessel and gave very little assistance to the perishing passengers aft.

Had the steamer been promptly stopped when the fire was first discovered, and the life-boats lowered, it is believed that all might have been saved, as the life-boats were very large and of sufficient capacity to save all aboard of the steamer. If the officers had done their duty and attended to their management there were between three and four hundred good cork jackets on board, in position accessible to the passengers, but two of which were used, by a Mr. Emmerson [sic], for himself and child, both of whom were saved thereby.

The majority of the passengers were colored persons who were taken aboard along the route, and were ignorant of the uses of life-saving appliances or steamers. It was clearly proven in the investigation that the officers were criminally negligent in regard to duty and proper discipline aboard. The captain was running without a license as such at the time; he has since made application for a license to the local board at Baltimore and been refused on account of his proven incompetency. The license of the chief engineer of the steamer was also revoked on account of his unofficer-like conduct at the time of the disaster.

The board of investigation fully exonerate the local inspectors at Baltimore who made the previous annual inspection of the steamer from all blame in the premises, as the steamer was fully equipped in accordance with the requirements of law.

Notes

Acknowledgements

1. http://familytreemaker.genealogy.com/users/c/o/l/Arica-L-Coleman/ TR, accessed June 30, 2009.

Introduction

2. In his book, *A History of the American People*, Johnson quotes President Lincoln speaking to a delegation of African Americans during the war: "There is an unwillingness on the part of our [white] people, harsh as it may be, for you free colored people to remain with us." See pages 496–97.
3. Claude G. Bowers writes in his book, *The Tragic Era*, of riots begun when black men in southern cities attempted to sit with white persons. "In Richmond, the blacks, determined to ride with the whites, rushed the street cars, and troops were necessary to restore order," he wrote. In another Virginia city, Norfolk, "negroes marched belligerently through the streets rattling firearms, the races clashed, with two fatalities on each side." See page 201.

CHAPTER 1

4. Whitman left Washington on May 20, 1873, his left arm and leg paralyzed. He had worked in several federal offices in the few preceding years while some of his poetry was being published and becoming widely read. The University of California at San Diego has made available on the Internet a complete copy of *Calamus: A Series of Letters Written During the Years 1868–1880 by Walt Whitman to a Young Friend (Peter Doyle)*. The title *Calamus* is in reference to Kalamos. In Greek mythology, he turned into a reed in grieving for his young male lover, Karpos, who drowned. See Bucke, Richard Maurice in bibliography. Dr. Bucke was one of Whitman's literary executors. The original letters had been edited to refer to Doyle only as "P." None of Doyle's letters are in the collection. For John Addington Symonds, Doyle's letters could not have added to Whitman's writing. "[I]t is clear he was only an artless and uncultured workman," Symonds wrote in *Walt Whitman A Study* (pages 78–79). Peter Doyle and his brother, Francis, the first Metropolitan District police officer killed on duty (1871), are buried in the family plot at Historic Congressional Cemetery.
5. *Whalemen's Shipping List And Merchants' Transcript*, August 19, 1873, p. 1.
6. The Potomac River was a major highway for carrying troops. The *New York Times* reported on August 15, 1862, on the collision of the steamers *West Point* and *George Peabody*, the latter carrying 280 wounded soldiers. The site near Aquia Point, Virginia, was soon filled with rescue vessels. In all, 76 died.
7. Dr. Child was the brother-in-law of Cornelia Hancock, and this report is included in her book *Letters of a Civil War Nurse*. Hancock describes similar experiences in the general Fredericksburg, Virginia area. She was assigned duty by the Sanitary Commission, as the Union army called its medical corps.
8. Newspapers covering the steamer's activities in 1873 referred to the owning company as both Potomac Steamboat Company and Potomac Ferry Company. In fact, the federal government license was made out in the name of the Washington Ferry Company. Most often used was Potomac Ferry Company, as it is in this book.
9. http://www.nauticalcharts.noaa.gov/nsd/distances-ports/distances.pdf.
10. "The Rambler Recalls," *Washington Star*, May 9, 1920. He also wrote that "patronized by excursionists were Green Spring above Georgetown, Mount Vernon Spring, White Horse (now on the Camp Humphreys tract), and Analostan Island [now known as Theodore Roosevelt Island]

and Arlington Spring, now on the Arlington experimental farm privately patronized by Washington excursionists."

11. The United States Steamboat Inspection Service, which licensed such vessels, gave the *Wawaset*'s tonnage as "328 90-100 tons burden." The "258 tons" in the Lytle-Holdcamper List was apparently the weight of the empty vessel, and "328.9" in the USSIS was the weight when loaded. Several modern dictionaries of naval terms do not include a definition for "burden" or "burthen." *Jane's Dictionary of Naval Terms* (pages 264–65) has a dozen definitions for variants of the words "ton" and "tonnage," including "displacement tonnage," "deep displacement" for fully loaded and the more easily understood in modern parlance "net" and "gross" tonnage.

12. The Lytle-Holdcamper List contains fourteen vessels with that name, but it appears that only this *Express*, number 7063, could have been on the Potomac in 1873.

13. Unless otherwise noted, all statistical information about steamboats is from the book *Merchant Steam Vessels of the United States, 1790-1868*, also known as the Lytle-Holdcamper List.

14. Holly, *Tidewater by Steamboat*, 82.

15. http://www.OldCompany.com, accessed July 10, 2009. The *Excelsior* had begun service between Washington and the Aquia Creek terminus, serving Richmond and Fredericksburg, Virginia, and ran between Washington and Quantico, Virginia, until 1872. Its later service was between Washington and Norfolk, Virginia.

16. A federal commission that examined the disaster that was to occur later that day further described the *Wawaset* as having "two good and efficient fire extinguishers (Gardner's), one good steam fire pump worked by steam (Woodward's patent) with suitable pipes leading therefrom and fitted and supplied as required by law, and one good double-acting fire pump worked by hand, furnished with one hundred seventy-five feet of good hose with nozzles and couplings complete, all being fitted to suit both steam and hand pumps; twenty-four fire buckets; five axes; one lifeboat made of metal and one of wood, all equipped complete; seventy-five life preservers, adjustable to the body, each containing six pounds of good cork and having a buoyancy of at least twenty-five pounds; sufficient and reliable steering apparatus, suitable arrangements for signaling the engineer from the pilot house with steam whistle and signal lights complete."

17. Throughout this book, the 1873–2009 conversion rate of 1:18 is based on "Consumer Price Index Conversion Factors" determined by Robert C.

Sahr, Oregon State University, and S. Morgan Friedman's www.westegg. com/inflation.cgi. Other conversion charts may vary by a few fractions.

18. The *Washington Star* that May 27 carried the announcement. The newspaper's "Rambler" column on May 9, 1920, recalled that Glymont's "most popular period was in the early 1870s when the steamboats *Wawaset* and *Mary Washington* carried excursionists there."

19. *Decisions of the Department of the Interior*, vol. III, 1890. In 1878, Mrs. Krause was denied a military pension because her husband had not been on duty when he died.

20. In *Ship Ablaze*, Edward T. O'Donnell writes that if USSIS inspectors "indicated an interest in [testing equipment] it usually meant they were angling for a larger bribe to look the other way," p. 51.

21. Holly, *Tidewater by Steamboat*, 82.

22. Gutheim, *Potomac*, 324.

23. *Webster's Revised Unabridged Dictionary (1913)*: "Hurricane deck (River Steamers, etc.), the upper deck, usually a light deck, erected above the frame of the hull."

24. Elsie Fowke Jackson, *Fowke and Mason Families*, vol. VIII, no. 1 (Northern Neck of Virginia Historical Society, n.d.), p. 733.

25. Foner and Mahoney, *America's Reconstruction*, 37. This study covers African American efforts to improve public education, notably the founding of today's Fisk University in 1866, Hampton University in 1868 and Howard University in 1869.

26. The *Washington Star* also reported on August 9, 1873, that not all adult passengers had been registered.

27. "A Standard History of the City of Washington from a Study of the Original Sources—1914," http://www/scripophily.net/estexcowevil. html, accessed July 10, 2009.

28. Fogle, *Neighborhood Guide*, 7. Fogle also describes Washington's Northern Liberties Farmers Market, 1846–72, at Mount Vernon Square, and the Eastern Market on Seventh Street, opened in 1871 with eighty-five vendor stalls.

29. The city directories for 1872 and 1873 give Joseph W. Reed as living at 715 Seventh Street Southwest. The other brothers were Bushrod Muse Reed, a captain in the Metropolitan Police Department, and Robert.

30. The *Gazette*, on August 9, 1873, also reported that Sallie Reed was a niece of Mrs. Thomas Finnall of Alexandria.

31. *Washington Star*, August 9, 1873. Many of the details of the trip and disaster are from the *Star*'s reportage within the week following the

tragedy. Unless otherwise referenced, readers can accept the *Star* as the source of information.

CHAPTER 2

32. The *Ledger* had much earlier corrected the spelling of the steamboat's name when it reported seasonal schedule changes in its neighborly way on December 20, 1872: "The *Wenonah,* which will leave Baltimore on next Tuesday, the 24th, will make her last trip from this place on next Thursday, the 26th. Those who are interested had better take notice." The news was more cheerful by February 11, 1873, when the newspaper announced that "an extra boat, the *Theodore Weems,*" was beginning the spring service that week. On September 9, 1873, the paper reported that the Baltimore–Fredericksburg steamers "are now doing the heaviest freight business ever done on the Rappahannock."

33. Plowden, *Farewell to Steam,* 87.

34. Froncek, *City of Washington,* 57. In *How the States Got Their Shapes* (page 60), Mark Stein writes of President Washington's finding the ten square miles that Congress had authorized to create the new federal district. The area was "located between the Maryland community of Georgetown and the mouth of the Anacostia." In "a backwater of swamps just below the rapids of the Potomac," Stein wrote, "[a] bug-ridden backwater became the nation's capital."

35. Graham, *Potomac: The Nation's River,* 111.

36. Wilstach, *Potomac Landings,* 50.

37. Higgins & Gerstenmaier in 2006 prepared a map, *Steamboat Ports of the Chesapeake Bay.* Based on research attributed to Jack Long, the map shows nineteen Virginia ports, west to east, as follows: Alexandria, Mount Vernon, Occoquan Bay, Quantico, Aquia Creek, Chatterton's Landing, Smith's, Colonial Beach, Mathias Point (incorrectly shown on the Maryland side), Kinsale, Mundy Point, Lidge, Ludwisetta, Cowarts, Lakes, Bundick, Coan, Walnut Point and Smith Point. The thirteen Maryland ports, west to east, follow: Riverview, Fort Washington, Marshall Hall, Glymont, Liverpool Point, Riverside, Morgantown, Rock Point, Piney Point, Adams, Millers, Smith Creek and Point Lookout.

38. *Washington Star,* May 9, 1920, "Rambler."

39. In his book *Portraits of the Riverboats,* Davis adds: "No wonder that the average life of a paddlewheeler on the big river trade was no more than

six or seven years before it either went down in flames or on a snag, or else was broken up by its owner so that he could reuse its machinery and appointments in a newer, larger boat."

40. Tilp included the *Wawaset* disaster in his comprehensive *This Was Potomac River*, pp. 110–14.

41. The Lytle-Holdcamper List, "Losses of United States Merchant Steam Vessels, 1790–1868."

42. All details about the *Sultana* in this chapter are from Jerry O. Potter's book *The Sultana Tragedy: America's Greatest Maritime Disaster.*

43. Potter, *Sultana Tragedy*, 81.

44. Howland, *Steamboat Disasters and Railroad Accidents in the United States.*

45. Bucke, *Calamus.* This note was written on the fly leaf of a copy of "Specimen Days" sent to Doyle at Washington in 1883.

46. Johnson, *A History of the American People*, 507.

47. Bowers, *The Tragic Era*, v.

48. In *The South*, Trowbridge added: "The poor whites may be divided into three classes: those who, to their hatred of the negro, join a hatred of the government that has set him free; those who associate with the negro, and care nothing for any government; and those who, cherishing more or less Union sentiment, rejoice to see the old aristocracy overthrown," p. 584.

49. Sandra Schmidt, a historian at the Historical Congressional Cemetery, is researching the MPD preparatory to writing a book about the district police in the early decades.

50. *New York Times*, "Washington Notes," July 30, 1872.

51. Holly, *Tidewater by Steamboat*, 173.

52. Foner and Mahoney, *America's Reconstruction*, 11, 114.

53. Shomette, *Shipwrecks on the Chesapeake*, 190.

54. Columnist Elizabeth Lawrence's account appeared in the *Washington Post* on March 16, 1969, when she was the owner of Eagle's Nest. Mrs. Irwin was born Ann Douglas Marshall about 1805 and lived only three months after her granddaughter's death. Ann Irwin died on November 19, 1873, at Eagle's Nest. Her husband, James Irwin, died in 1855.

55. Wilstach, *Potomac Landings*, 152. Wilstach also notes the "Waughs' Belle Plaine" and recalls "a tradition that Martin VanBuren came in great style to Richlands [a few miles above Aquia Creek] in his coach behind four white horses and liveried footmen," p. 139.

56. In his book *The South*, Trowbridge describes continuing his 1865 trip to Fredericksburg and finding the city "had not yet begun to recover from the effects of Burnside's shells," p. 57.

57. A description of the region around Chatterton's Landing as it existed in the 1870s was given years later by the *Washington Star* columnist called the "Rambler": Chatterton's Landing "lies between Stiff's (Stith's) Wharf and Somerset Beach, a short distance west of Eagle's Nest Landing, now only a memory. Chatterton House is just back from the river a little way. It was the home of Col. John Tayloe…his son, Forrest, now lives on part of the estate."

58. Elizabeth Lawrence, *Washington Post*, March 16, 1969.

59. "Virginia Gleanings in England: Abstracts of 17th and 18th-Century English Wills and Administrations Relating to Virginia and Virginians: A Consolidation of Articles," *Virginia Magazine of History and Biography* (1980).

60. Wilstach, *Potomac Landings*, 341.

CHAPTER 3

61. "At an Old Grave" was among several offerings in a section covering attitudes and aspects of death appearing in *Harper's Magazine* in September 1873, p. 513.

62. Reconstruction of the drama aboard the steamboat and through the federal hearing is based on accounts in several newspapers in the next few weeks after August 8, 1873. *New York Times* and *Washington Star* accounts were generally carried to other newspapers around the country by the Associated Press, which originated some of its own reports also.

63. Frederick Tilp's *This Was Potomac River* locates the area as between Maryland Point and Persimmon Point, just above Colonial Beach in Virginia. Other statistics listed with a front cover map, all in nautical miles, are: total length from Fairfax Stone, West Virginia, to the Potomac River mouth, 385; distance from Tidewater Little Falls, Maryland, to the mouth, 104; greatest width, from Thicket Point, Virginia, to Kitts Point, Maryland, 6.4 miles; and greatest diagonal width, from Point Lookout, Maryland, to Smith Point, Virginia, 9.5 miles.

CHAPTER 4

64. *Washington Star*, October 31, 1915, "Rambler," 217.

65. Fannie Grymes was the widow of Thomas Jefferson Independence Grymes, who died in 1866. A newspaper reported in error that Kate McPherson went to the home of "Mr. Grimes."

NOTES TO PAGES 55–76

66. Tilp, *This Was Potomac River*, 45–51. He tells how Maine ships would bring ice to Georgetown and load up with coal for the return trip, thus helping cool the District of Columbia in summertime and heat Maine in the winters. When coal-laden ships occasionally stuck on "shoal bumps," help was gladly offered by Potomac residents in return for coal to help with their winter heating.

67. Tilp, *This Was Potomac River*, 17–18; cites a Union war policy as contributing to the river's loss of sustainable fishing levels. G.V. Fox, assistant secretary of the navy, oversaw a "scorched earth" program designed to rob Confederate states of a rich food source.

68. Potter, *Sultana Tragedy*, 178; cites an *Argus* story dated May 5, 1865, p. 6.

CHAPTER 5

69. Fielding Lewis lived at Marmion, the neighboring farm of Eagle's Nest and Chatterton. Marmion was originally a Fitzhugh home. Fielding Lewis was the great-grandson of Fielding Lewis and Elizabeth "Betty" Washington Lewis and great-great-nephew of President George Washington.

70. Schantz, *Awaiting the Heavenly Country*, 4, 93–94, 163–72.

71. For a discussion of the history of embalming, see the Google American Libraries free download, an 1840 "History of Embalming" by Jean-Nicholas Gannal and Richard Harlan.

72. Charles G. McClelland, often misspelled "McLelland," was probably a Union officer in the Civil War. Born in Scotland, he was residing in the King George County community of Passapatanzy in the 1870s, according to the United States census.

73. Fannie Taylor had boarded in Washington with a child, and both were to be declared dead.

CHAPTER 6

74. August 21, 1873, vol. XII, no. 8, p. 120. The *Chronicle* was published weekly in New York and had a national circulation.

75. Smith was a hardworking, hands-on supervisor, plain-spoken and in some ways outspoken, although he was considered ethical, expert in his knowledge of steam-driven vessels and devoted to safety. The congressional

NOTES TO PAGES 76–92

commission that he headed was planning nine experiments to study every known way that steam boilers exploded. This activity was unrelated to the *Wawaset*, which went down because of fire. Boiler explosions, however, were the leading cause of steamboat and railroad accidents.

76. Lloyd M. Short, *Steamboat-Inspection Service: Its History, Activities and Organizations*, Institute for Government Research Monograph no. 8. The USSIS was transferred from the Department of the Treasury to the Department of Commerce and Labor in 1903 and to the Department of Commerce alone in 1913. In 1936, the service was consolidated with the Bureau of Marine Inspection and Navigation. www.archives.gov/research/guide-fed-records/groups/041.html.

77. Short's study covers the 1852 law that suggests the importance of steamboat service by requiring the United States president to appoint the nine supervisors "with the advice and consent of the Senate." The supervisors in turn were to meet annually to oversee uniform administration of inspection laws. The secretary of the treasury was to have final approval over appointment of a collector or other chief officer of customs in each district. The fees the latter officer collected were to be turned over to the national treasury. Regulations brought a "rather prevalent hostility and opposition to the inspection laws…especially among the officers and owners of vessels," but by 1862 everyone seemed to accept that "the cause of almost every accident to passenger steamers which now occurs can be readily traced to a violation of its provisions."

78. A legal question apparently never made public concerns whether any Virginia body had the authority to address the fatal journey on a river that is defined as being wholly within the state of Maryland.

CHAPTER 8

79. These two boats apparently were similar in size to the *Wawaset*. The *Kent* was built in 1854 in Baltimore and was listed at 266 tons. The *Palisade*'s size is not given, although it is also on the Lytle-Holdcamper List.

80. Throughout the 1800s, newspapers copied stories from one another and gave credit. This one was copied by the *Fredericksburg Ledger* and was printed on August 29, 1873. The phrase "passed even" seems to have meant "without praise and without criticism."

81. The *Washington Post*, on August 22, 1911, reported on the district commission's giving consideration to "a monument in memory of the

seventy Washingtonians who perished in the burning of the steamer *Wawasett* August 8, 1873." The plan failed to receive support.

82. The *Washington Star*, on October 15, told how Sarah Reed's long journey to a final resting place continued: "Mr. Reed had previously arranged for the interment yesterday at 3 o'clock p.m. By some unfortunate misunderstanding between the undertaker and the sexton at the Congressional burying ground, however, the grave was not prepared, and the relatives and friends of the family who had assembled to witness the last rite were disappointed, and the interment was necessarily delayed again until 3 o'clock today, the remains in the meantime being placed in a vault."

83. Historian Sandra Schmidt notes that Joseph Reed married twice more after 1873 and was living with his son Warren in Washington at the time of his death. All four of his wives are buried in the same cemetery. Joe's first wife, Rosalie F., died in 1871, leaving him with the three children who were drowned near Chatterton's Landing with his second wife, Sarah Walker Reed; his third wife, Julia Virginia, was the mother of Joe's sons Warren, who was fifty years old at the time of his father's death at age ninety-one in 1928, and Owen E., who was only four months old when he died in 1880, two months before his mother. Joe and Julia were married less than four years. Joseph married his fourth wife, Elizabeth E., in 1890, and she died in 1917.

84. *Washington Parish Burial Ground*, 3. Other information came from this small book, historian Schmidt and a report by James Croggon in the *Evening Star* on June 1, 1912.

85. Clinton's body was removed in 1908 and returned to New York for burial.

86. http://memory.loc.gov/cgr-bin/query/D/nn.2../temp.

87. Deaths were reported to the Virginia Bureau of Vital Statistics from 1853 through 1896 and then from 1912 to the present. Earlier death reports did not record where burial took place.

88. Foner and Mahoney, *America's Reconstruction*, 97.

89. Smoot, *Days in an Old Town*, 46.

90. This quotation comes from a story in the *Washington Star* on August 9, 1873; it was also printed on August 13 in the *Chicago Tribune*.

91. Plowden, *Farewell to Steam*, 2.

Bibliography

Anderson, Elizabeth Stanton, ed. *Steam Vessels of Chesapeake and Delaware Bays and Rivers: Drawings by Samuel Ward Stanton.* Meriden, CT: Printed at the Meriden Gravure Company, 1966..

Bowers, Claude G. *The Tragic Era: The Revolution after Lincoln.* Cambridge, MA: The Riverside Press, 1929.

Bucke, Richard Maurice, MD, ed. *Calamus: A Series of Letters Written During the Years 1868–1880 by Walt Whitman to a Young Friend (Peter Doyle).* Boston: Small, Maynard & Company, 1898.

Casper, Scott E. *Sarah Johnson's Mount Vernon: The Forgotten History of an American Shrine.* New York: Hill and Wang, 2008.

Chant, Christopher. *The Complete Encyclopedia of Steamships: Merchant Steamships 1798–2006.* Illustrated by John Batchelor. Lisse, Netherlands: Rebo International and Publishing Solutions, 2007.

Cozzens, Peter. *Shenandoah 1862: Stonewall Jackson's Valley Campaign.* Chapel Hill: University of North Carolina Press, 2008.

Davis, William C. *Portraits of the Riverboats.* San Diego, CA: Thunder Bay Press, 2001.

Davis, William C., and James I. Robertson Jr., eds. *Virginia at War 1863.* Lexington: University Press of Kentucky, 2009.

Dunn, Susan. *Dominion of Memories: Jefferson, Madison and the Decline of Virginia.* Cambridge, MA: Basic Books, 2007.

Eubank, H. Ragland. *The Authentic Guide Book of Historic Northern Neck of Virginia: The Land of George Washington and Robert E. Lee.* Richmond, VA: Whittet & Shepperson, 1934.

Fogle, Jeanne. *A Neighborhood Guide to Washington, D.C.'s Hidden History.* Illustrated by Edward Fogle. Charleston, SC: The History Press, 2009.

Foner, Eric, and Olivia Mahoney. *America's Reconstruction: People and Politics after the Civil War.* Baton Rouge: Louisiana State University Press, 1997.

Froncek, Thomas, ed. *The City of Washington.* New York: Alfred A. Knopf, 1985.

Garrison, Webb, with Cheryl Garrison. *The Encyclopedia of Civil War Usage: An Illustrated Compendium of the Everyday Language of Soldiers and Civilians.* New York: Castle Books, 2009.

Graham, Frank, Jr. *Potomac: The Nation's River.* Philadelphia and New York J.B. Lippincott Company, 1976.

Gutheim, Frederick. *The Potomac.* New York: Holt, Rinehart and Winston, 1949.

Holly, David C. *Chesapeake Steamboats: Vanished Fleet.* Centreville, MD: Tidewater Publishers, 1969.

———. *Tidewater by Steamboat: A Saga of the Chesapeake.* Baltimore, MD: Johns Hopkins Press, 1991.

Howland, S.A. *Steamboat Disasters and Railroad Accidents in the United State: To Which Is Appended Accounts of Recent Shipwrecks, Fires at Sea, Thrilling Incidents, &c.* 2nd edition. Worcester, MA: Dorr, Howland & Co., 1840.

Jaquette, Henrietta Stratton, ed. *Letters of a Civil War Nurse: Cornelia Hancock, 1863–1865.* Lincoln: University of Nebraska Press, 1998.

Jessop, Violet. *Titanic Survivor: The Newly Discovered Memoirs of Violet Jessop, Who Survived both the Titanic and Britannic Disasters.* Edited by John Maxtone-Graham. Dobbs Ferry, NY: Sheridan House, Inc., 1997.

Johnson, Paul. *A History of the American People.* New York: HarperCollins Publishers, Inc., 1999.

Klapthor, Margaret Brown, and Paul Dennis Brown. *The History of Charles County, Maryland.* LaPlata, MD: Charles County Tercentenary, Inc., 1958.

Lee, Elizabeth Nuckols, and Jean Moore Graham. *King George County: A Pictorial History.* Virginia Beach, VA: The Donning Company Publishers, 2006.

Linder, Bruce. *Tidewater's Navy: An Illustrated History.* Annapolis, MD: Naval Institute Press, 2005.

McClintock, Anne L. *Steamboats.* Irvington, VA: Steamboat Era Museum, 2009.

Metcalf, Paul. *Waters of Potowmack.* San Francisco: North Point Press, 1982.

Mitchell, C. Bradford, ed. *Merchant Steam Vessels of the United States, 1790–1868.* "The Lytle-Holdcamper List." Staten Island, NY: Steamship Historical Society of America, Inc., 1975.

O'Donnell, Edward T. *Ship Ablaze: The Tragedy of the Steamboat General Slocum.* New York: Broadway Books, 2003.

Palmer, Joseph, comp. *Jane's Dictionary of Naval Terms*. London: Macdonald and Jane's Limited, 1975.

Perry, John. *American Ferryboats*. New York: Wilfred Funk, Inc., 1957.

Plowden, David. *Farewell to Steam*. Brattleboro, VT: Stephen Greene Press, 1966.

Potter, Jerry O. *The Sultana Tragedy: America's Greatest Maritime Disaster*. Gretna, LA: Pelican Publishing Company, Inc., 1992.

Preble, George Henry. *Notes for a History of Steam Navigation*. Philadelphia: J.B. Lippincott & Co., 1881.

Rogers, John G. *Origins of Sea Terms*. Mystic, CT: Mystic Seaport Museum, Inc., 1985.

Schantz, Mark S. *Awaiting the Heavenly Country: The Civil War and America's Culture of Death*. Ithaca, NY: Cornell University Press, 2008.

Shomette, Donald G. *Shipwrecks on the Chesapeake: Maritime Disasters on Chesapeake Bay and Its Tributaries, 1608–1978*. Centreville, MD: Tidewater Publishers, 1982.

Short, Lloyd M. *Steamboat-Inspection Service: Its History, Activities and Organization*. New York: D. Appleton and Company, 1922.

Smoot, Betty Carter. *Days in an Old Town*. Alexandria, VA, 1934.

Stein, Mark. *How the States Got Their Shapes*. New York: HarperCollins Publishers, Smithsonian Books, 2008.

Stout, Harry S. *Upon the Altar of the Nation: A Moral History of the Civil War*. New York: Viking/Penguin Group, 2006.

Tilp, Frederick. *This Was Potomac River*. Original 1978 edition, reprinted with new material, prologue and epilogue by Michelle A. Krowl and Bradley E. Gernand. Ashburn, VA: Richard R. Willich, publisher, 2006.

Trowbridge, John Townsend. *The Desolate South: A Picture of the Battlefields and of the Devastated Confederacy*. Edited by Gordon Carroll. Freeport, NY: Books for Libraries Press, 1970.

———. *The South: A Tour of Its Battlefields and Ruined Cities, A Journey through the Desolated States, and Talks with the People, 1867*. Edited by J.H. Segars. Macon, GA: Mercer University Press, 2006.

Washington Parish Burial Ground (Congressional Cemetery) 1807–1913. Washington, D.C.: The Vestry, Washington Parish [Christ Church Episcopal], 1913.

Wilstach, Paul. *Potomac Landings*. New York: Tudor Publishing, 1937.

Withington, Lothrop. "Virginia Gleanings in England: Abstracts of 17th and 18th-Century English Wills and Administrations Relating to Virginia and Virginians: A Consolidation of Articles." *Virginia Magazine of History and Biography* (1980).

About the Author

Alvin Oickle is the author of two other recent "disaster books" from The History Press: *Disaster in Lawrence: The Fall of the Pemberton Mill* and *Disaster at Dawn: The Cedar Keys Hurricane of 1896*. His other nineteenth-century history books include *Jonathan Walker: The Man with the Branded Hand*. Al has been an Associated Press feature writer, a daily newspaper editor and a writing instructor at the University of Massachusetts–Amherst. His long career in journalism has also extended into broadcasting.